Close-Up and Macro Photography

Close-Up and Macro Photography

Adrian Davies

ELSEVIER

AMSTERDAM • BOSTON • HEIDELBERG • LONDON • NEW YORK • OXFORD
PARIS • SAN DIEGO • SAN FRANCISCO • SINGAPORE • SYDNEY • TOKYO
Focal Press is an imprint of Elsevier

Focal Press is an imprint of Elsevier
30 Corporate Drive, Suite 400, Burlington, MA 01803, USA
Linacre House, Jordan Hill, Oxford OX2 8DP, UK

Notices
Knowledge and best practice in this field are constantly changing. As new research and experience broaden our understanding, changes in research methods, professional practices, or medical treatment may become necessary.

Practitioners and researchers must always rely on their own experience and knowledge in evaluating and using any information, methods, compounds, or experiments described herein. In using such information or methods they should be mindful of their own safety and the safety of others, including parties for whom they have a professional responsibility.

To the fullest extent of the law, neither the Publisher nor the authors, contributors, or editors, assume any liability for any injury and/or damage to persons or property as a matter of products liability, negligence or otherwise, or from any use or operation of any methods, products, instructions, or ideas contained in the material herein.

∞ Recognizing the importance of preserving what has been written, Elsevier prints its books on acid-free paper whenever possible.

Library of Congress Cataloging-in-Publication Data
Davies, Adrian, 1953-
 Close-up and macro photography / Adrian Davies.
 p. cm.
 Includes bibliographical references and index.
 ISBN 978-0-240-81212-0 (pbk. : alk. paper)
 1. Photography, Close-up. 2. Macrophotography. I. Title.
TR684.D377 2010
778.3′24–dc22

2009026234

British Library Cataloguing-in-Publication Data
A catalogue record for this book is available from the British Library.

ISBN: 978-0-240-81212-0

For information on all Focal Press publications visit our website at www.books.elsevier.com

09 10 11 12 13 5 4 3 2 1

Printed in China

Working together to grow
libraries in developing countries

www.elsevier.com | www.bookaid.org | www.sabre.org

ELSEVIER BOOK AID International Sabre Foundation

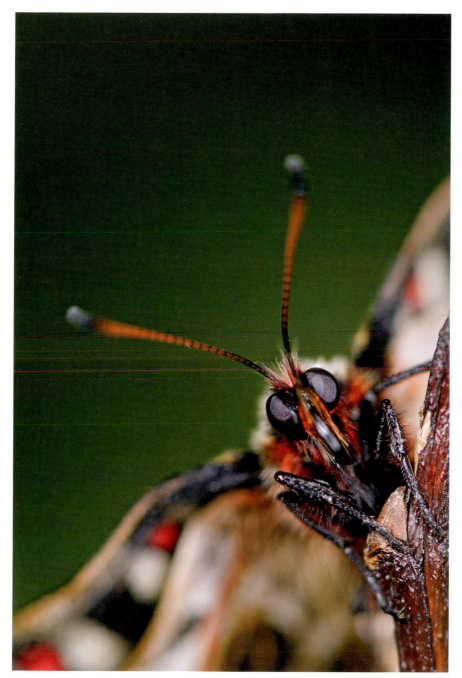

Head of Spanish Festoon butterfly. Nikon 105mm Micro Nikkor lens. Twin flash setup. $\frac{1}{60}$ @ f/8

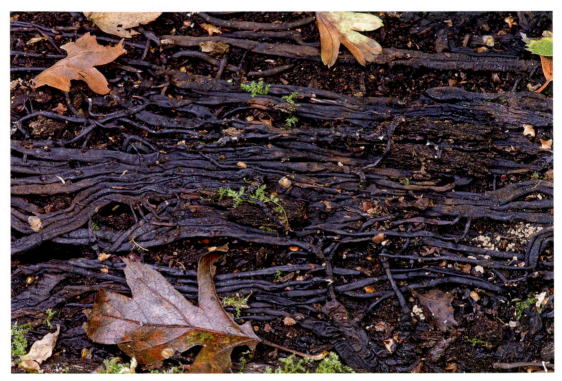

Rhizomorphs of Honey Fungus on fallen log. Specimens can sometimes be glowing after dark. A simple close-up in natural light. Nikon D300, 105mm Micro-Nikkor. 1 sec @ f/11. Benbo tripod.

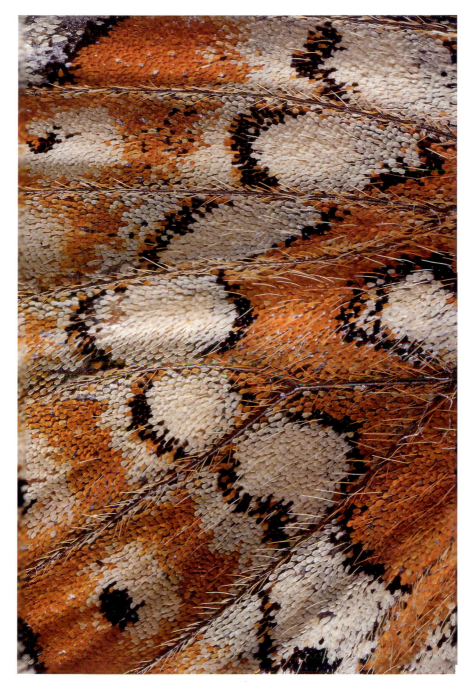

Wing of Marsh Fritillary butterfly (set specimen). 3 image "stack". Each image $\frac{1}{125}$ sec @f/8 Nikon D300 with 105mm Micro-Nikkor lens

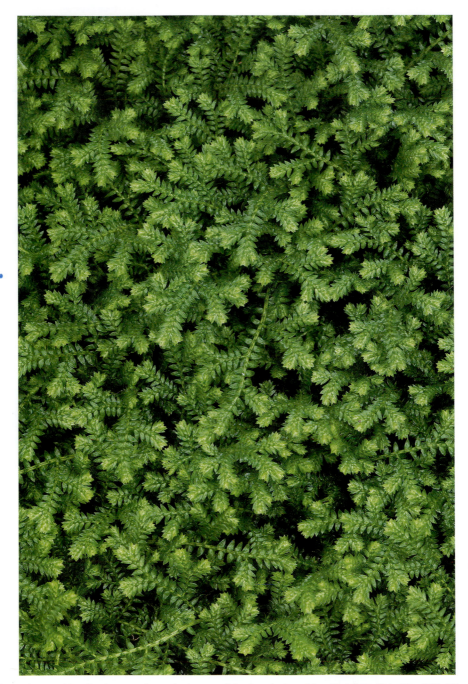

Selaginella moss. I was careful to align the sensor plane so that it was parallel to the main plane of the subject. Natural light. Nikon D300. 105mm Micro-Nikkor lens. $\frac{1}{5}$ sec @f/16

Tendril of Passion flower, showing change of direction of twist. Specimen mounted in "helping hand" support. Studio, with diffuse natural light. Nikon D300. 105mm Micro-Nikkor lens. 1 sec @ f/11

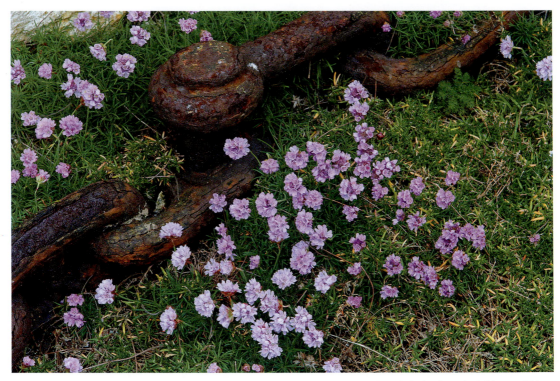

Thrift and rusty chain. I particularly liked the contrast between the fresh spring flowers and the rusty sea chain which I found outside a lighthouse in Wales. Natural light. Nikon D300. 17 – 55mm Nikkor lens set to 55mm. $\frac{1}{100}$ sec @ f/9

Contents

Contents

Contents

Acknowledgments

As always, a huge thanks to my wife and family for putting up with my extended periods either in the field or at my desk. A special thanks to my children, Bryony and Robin, who both helped out with some of the photography.

Thank you to the staff at Focal Press, Ben Denne and Danielle Monroe, for helping with the production and answering my numerous questions.

Thank you to the following for helping with equipment or specimens:

Grahame Sandling, Crime Scene Investigation Equipment Ltd., for providing samples of macro scales.
David Johnson, Speed Graphic, for images of Novoflex's close-up equipment.
Shareen Brown, Canon (U.K.) Ltd.
David Robbins, John MacDonald, and Alex O'Brien, Nikon (U.K.) Ltd.
Cynthia S. Fenton, Wimberley, for the Wimberley Plamp support
Gloria Attwell, Steve Smith, and Marcus Latter, NESCOT College
Sarah Herd, Epson (U.K.) Ltd.
George and Donna Hudson, Lynwood Aquatics, www.lynwoodaquatics.co.uk, for allowing me to photograph their tropical fish.

Web Site

A Flickr site has been created where readers can post their own images for evaluation, and see new images from Adrian Davies.

http://www.flickr.com/photos/macrobook/

Introduction

Close-up and macro photography are two of the most challenging forms of photography, yet potentially the most exciting and rewarding, often revealing stunning patterns, textures, colors, and details unseen by the naked eye. Everyday objects can make excellent macro subjects, providing an endless range of specimens. Whilst medical and forensic photographers need to be able to record the finest details in a standardized way in their images, artists and creative photographers will find huge inspiration in the myriad of subjects to be found in the world of close-up and macro photography. New advances in digital equipment have made it much easier recently, particularly as results can be previewed instantly on the camera screen, and, with no film and processing costs, there is now no need to worry about the cost of experimentation. Advances in software too, enabling new techniques such as focus stacking, have led to new standards in close-up imaging that were unimaginable just a few years ago.

Good close-up and macro photography do not come easily though. They require meticulous technique, perseverance, and patience. Many of the images in this book are the result of much frustration and several reshoots. I have explored various subjects in my quest to obtain appropriate and often unusual images for this book, from familiar peacock feathers and flowers,

FIGURE 1.1 This delicate flower, *Brillantaisia owariensis*, took a long time to shoot; first, to find a good specimen with an uncluttered background, then to take the time to wait for the wind to die down so that it was perfectly still. The camera was mounted on a sturdy tripod, and the exposure was made with the mirror lock-up facility. Camera: Nikon D300, 105 mm Micro-Nikkor, $\frac{1}{60}$ sec. at f/5.6.

to the less obvious, such as hedgehog spines and dentists drills. (I had no idea what the tip of a dental drill looked like until I saw one for the first time through the camera viewfinder!)

The choice of lens is critical, and this book will examine in detail the types of lenses most appropriate for this type of photography, and how to get the best results from them. The lens used will help determine viewpoint and depth of field, which is a critical issue in close-up and macro photography, both in terms of the main subject, and the background behind it. In Chapter 3 we examine depth of field and various factors behind it, and how to achieve the best compromise between image quality and subject depth.

As with any form of photography, quality and direction of light is fundamental to the success of the image, and this book will deal extensively with light, and how to use and enhance it where necessary.

Flatbed scanners can be utilized to give superb macro images with minimum effort, and the various techniques that can be used with those devices will be explored in detail.

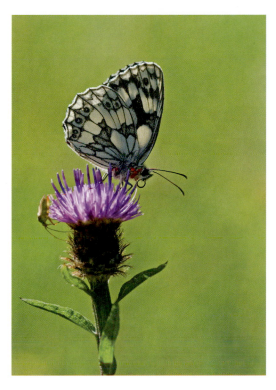

FIGURE 1.2 This image of a Marbled White butterfly was, by contrast to Figure 1.1, shot very quickly. This particular species always visits purple flowers, and I waited next to one to see if the butterfly would land there. It stayed long enough for just two exposures, shot with natural light. It was only when I reviewed the images afterward that I saw the red mites attached to the butterfly, just behind its head. Camera: Nikon D300, 105 mm Micro-Nikkor, $\frac{1}{320}$ sec. at f/5.6.

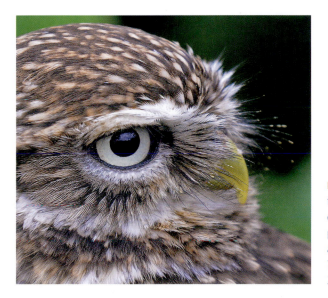

FIGURE 1.3 Only when you view a familiar subject close up, such as the eye of this owl, do the extraordinary pattern and variety of textures become apparent. Camera: Nikon D300, 70–200 mm Nikor lens, set to 200 mm, $\frac{1}{250}$ sec at f/5.6

FIGURE 1.4 Close-up photography is a great way of isolating shapes and patterns, such as the spiral of this nautilus shell. This specimen was photographed in a light tent using daylight. Camera: Nikon D300, 105 mm Micro-Nikkor, ½ sec. at f/11.

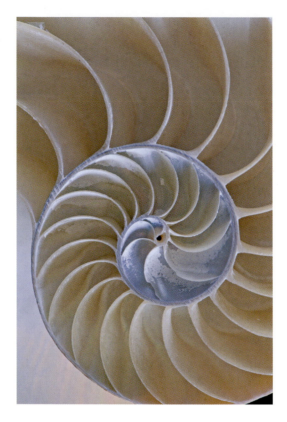

Definitions

Different authors and manufacturers use the terms *close-up photography* and *macro photography* in different ways, often meaning different things, and it is important that they are clarified right at the start. *Close-up photography* is usually applied to any situation where the subject is closer than "normal"—in other words, a rather vague and meaningless term. To a wildlife photographer, being within 15 feet of a hungry crocodile is close up! In this book, *close-up photography* describes when the subject is reproduced at around one-tenth of life size or greater on the image sensor in the camera.

The term *macro photography* has a more tightly defined definition, generally being used for photography where the subject is reproduced at a magnification of life size or greater. Magnifications up to around 4× or 5× are relatively easy with digital single-lens reflex cameras (SLRs) equipped with appropriate lenses and accessories. Beyond that, it may be necessary to use special optical bench assemblies and microscopes, which are outside the scope of this book.

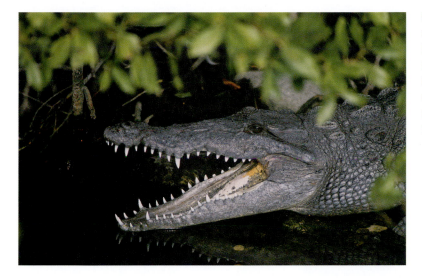

FIGURE 1.5 To many people this crocodile, photographed in the Florida Everglades, would seem like a close-up image (too close for some!), even though it was over 30 feet away, and photographed with a 300 mm telephoto lens. Camera: Nikon D200, 300 mm lens, $\frac{1}{60}$ sec. at f/8.

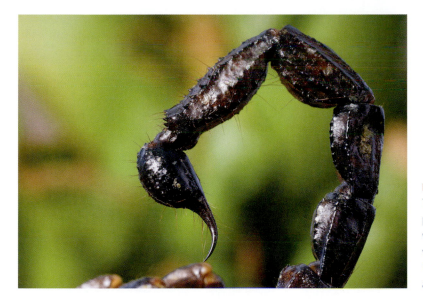

FIGURE 1.6 The tail of a scorpion. This would also be too close for many people. Remember: Take great care when photographing poisonous or venomous creatures! Camera: Kodak 14N, 105 mm Micro-Nikkor, $\frac{1}{125}$ sec. at f/22.

Micro is another related term worth mentioning. The term is applied to photographs taken with the aid of a microscope, strictly known as photomicroscopy. *Micro photography*, on the other hand, is the photography of large subjects and then making them into very small images such as micro dots, or the photography of, for example, large circuit boards and then making them small integrated circuits. (An old way of quantifying micro photography was to use the scale of "Bibles per square inch": How many

complete Bibles could be imaged onto one square inch of film!) Rather confusingly, Nikon calls their range of macro lenses Micro-Nikkors.

Reproduction Ratios

In the world of close-up and macro photography, we use the concept of reproduction ratios to give an indication of magnification. This is particularly important if you are trying to give a real indication of the subject's size for identification purposes.

If a 25-mm-long subject is focused so that it fits exactly onto a 25-mm imaging sensor, the reproduction ratio is 1 : 1, or 1×; that is, it is reproduced on the sensor at life size (all three of these terms are used in various books and other sources). If a 50-mm subject is focused so that it fits onto the same 25-mm

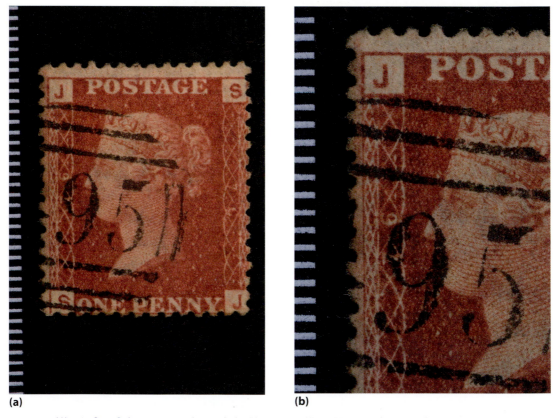

(a) **(b)**

FIGURE 1.7 A Victorian Penny Red postage stamp, photographed at (b) 1×, (c) 2×, (d) 3×, (e) 4×, and (f) 5× magnification. Figure 1.7a was photographed at approximately ×1/2 in the camera, and is shown here reproduced at a total magnification of approximately 2.5× life size. The scale to the left of the whole stamp is in millimeters, showing the stamp to be approximately 24 mm high. The stamp was lit with two small flash heads of equal power and equal distance from it. Camera: Canon 1000 D, MP-E65 macro lens.

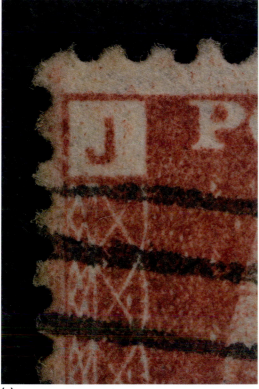
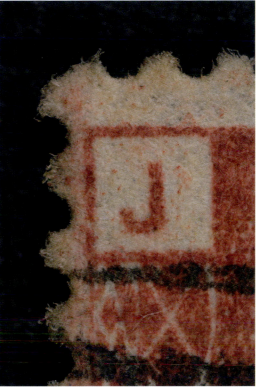

(c) **(d)**

FIGURE 1.7 *Continued*

sensor, then it is reproduced at half–life size, or a ratio of 1 : 2, or ½×. Similarly, if a 12.5-mm subject is focused so that it exactly fits the 25-mm sensor, then it will be reproduced at a magnification of twice its life size, or a ratio of 2 : 1, or 2×. It is quite common to talk about magnification ratios in photography (e.g. ¼×, ½×) where the subject isn't actually being magnified.

> 📖 **Magnification in the Camera**
>
> It is possible to determine the magnification through the camera viewfinder. Assuming that your viewfinder shows 100 percent of the sensor area, then by focusing on a ruler, the ratio between the length of the ruler scale shown in the viewfinder and the sensor can be found. Unfortunately, most viewfinders do not show the full sensor area, so this will only give an approximate magnification. The sensor size for your camera will be found from the technical specification in the camera instruction manual.

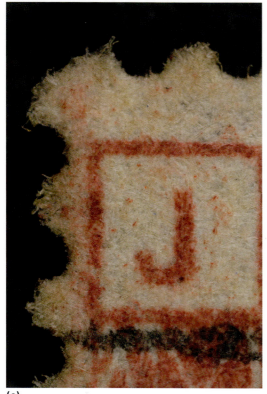

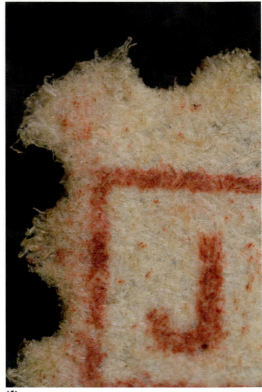

(e) **(f)**

FIGURE 1.7 *Continued*

Of course, the magnification at the image sensor is not very relevant if the image is going to be enlarged to a print or other form of display. The final magnification of the subject, therefore, will be derived from the magnification at the sensor (e.g., $\frac{1}{2}\times$) multiplied by the magnification required to make the final print size. For example, if the sensor size is approximately 24 × 16 mm, and the print size is 250 × 200 mm, this is an approximate linear enlargement of 10×. If the magnification of the subject at the sensor is $\frac{1}{2}\times$, then the final magnification is ($\frac{1}{2}\times$) × 10, or approximately 5× life size.

If it is important to know exactly the final magnification, or reproduction ratio, for scientific purposes, you can either place a scale alongside the subject to be included in the final image, or shoot two exposures—one of the subject and another of a scale placed in the subject plane. It is then easy to measure the final image of the ruler on the print and relate it to the original scale on the ruler.

Image Capture

Digital Cameras

Digital camera technology has improved vastly over the last few years, and is still rapidly evolving, with new camera designs and features being introduced almost on a daily basis, and relative costs falling too. The image quality nowadays from a good camera can be nothing short of outstanding if used properly, and with all its advantages over film, in particular, instantly viewable images, there has never been a better time for close-up photography.

There are three main types of camera in general use: compact, prosumer or "bridge," and single-lens reflex. They can all be used very successfully for close-up and macro photography, though some models will have specific limitations. Which type of camera and model you buy will depend largely on what you are going to do with the images, your budget, the subject matter, and your personal preference. Certainly, if you are going to be doing a lot of serious close-up and macro photography, and need the versatility and flexibility that it offers, then the best choice by far is an interchangeable-lens digital single-lens reflex camera (DSLR), and much of this book is aimed at

FIGURE 2.1 It would have been possible to photograph this lichen with any of the camera types discussed here. What is more important than camera type is technique—keeping the camera very still during the $\frac{1}{30}$-second exposure, and aligning the camera with the plane of the subject. Camera: Nikon D300, 105 mm Micro-Nikkor, $\frac{1}{30}$ sec. at f/16.

DSLR users. They can be heavy and bulky though, and if you need a camera to fit into your pocket, then a smaller model may be a better choice.

Compact Cameras

Compact cameras are generally small, lightweight cameras that can be carried in a pocket, but are still capable of outstanding results. Some models use an optical viewfinder separate from the lens that takes the picture. This can lead to parallax error, where the viewfinder sees a slightly different view of the subject than the lens actually taking the picture, leading to framing problems, particularly when used for close-ups. This is a major problem with film cameras, often leading to part of a subject being cut off. With digital cameras, however, this problem is largely solved because the image can be reviewed on the LCD display on the back of the camera. Many compact cameras nowadays do not have optical viewfinders at all. Instead, the camera is held away from the face and the image composed using the live image on the screen on the back of the camera. Images can be very difficult to see in bright sunshine, however, so this method doesn't lend itself to critically evaluating the whole of the image before the shot is taken, and therefore is generally not recommended for serious work.

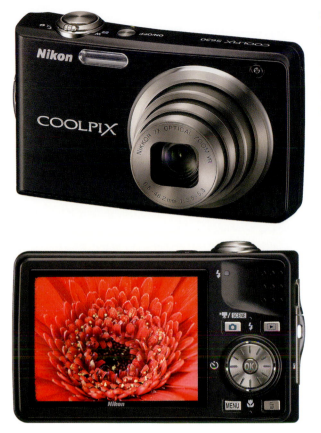

FIGURE 2.2 The Nikon S630, a typical 12-Mp (1 million pixels = 1 megapixel, Mp) digital compact camera with a 7× zoom lens (37–260 mm equivalent), capable of focusing down to 2 cm (0.8 in.). Notice the lack of an optical viewfinder.

Most compact cameras have zoom lenses—that is, a lens with a variable focal length. Typical ranges are 38–114 mm (3× zoom) or 36–180 mm (5× zoom), and most will focus very close to a subject, often down to 4 cm (1.7 in.) in macro mode. When used very close to a subject the amount of light falling on the subject may be blocked by the camera itself, and the built-in flash may miss the subject altogether by passing over the top of the lens.

The minimum aperture of most compact cameras is relatively large in comparison to their SLR cousins (typically f/5.6 or f/8), but due to the small size of the sensor, this may not be too much of a problem with regard to depth of field. Indeed, it may be difficult to obtain a sufficiently shallow depth of field if required. (See more on depth of field in Chapter 3.)

The majority of compact cameras have automatic focusing, which may not focus on the most important part of the subject in some cases (e.g., a spider's web). If you intend to use this type of camera primarily for close-up and macro work, choose a model with a manual focusing facility.

Several accessories are available for compact cameras to increase their macro capabilities, including ring flash units.

> 📖 **Shutter Lag**
>
> One significant issue with both compact and bridge cameras is that of "shutter lag," the time between the shutter button being depressed and the image being recorded. In these cameras it is usually around one-quarter to one-half of a second. These cameras use an electronic form of shutter known as interline transfer, which records images by effectively "sampling" the video signal generated by the sensor. It was developed for video cameras shooting at 30 frames per second, isolating an entire image in one instant, then gradually shifting it into the camera processor. The lag, or delay, is the time taken to shift the image into the processor. Because there are no mechanical components, the camera using this type of shutter can be very small. In early models, the time delay was quite a problem, and although they are much improved, it can still cause problems with moving subjects such as insects, or plants moving in a breeze.
>
> DSLRs, by contrast, use a full-frame system, utilizing a focal plane shutter (or diaphragm shutter in some larger models), where the entire sensor is exposed for the required amount of time before the shutter is closed again. There is virtually no delay with this system, and DSLRs can shoot several frames per second.

Prosumer, or "Bridge," SLRs

The prosumer camera is also referred to as a "bridge" camera because it is seen as the "bridge" between compact and DSLR cameras. The prosumer camera is a larger version of a compact camera, with a reflex viewing system and noninterchangeable lens. Reflex viewing systems negate any possibility of parallax error by taking the image through the same lens with which it is viewed. Bridge SLRs do not have a true optical viewfinder, but instead have an electronic viewfinder (EVF) that displays a small video image of the subject (which can usually be switched to the screen on the back of the camera). While the EVF is fine for most conventional photography, the rather coarse structure of the image is not suited for really critical focusing of close-up subjects. If you are considering this option, be sure to try it out first before you buy it.

Bridge cameras are usually equipped with zoom lenses, often with very wide ranges—for example, 27–486 mm (18×) in some models—and usually have a macro mode that can enable very close focusing—for example, down to 1 cm

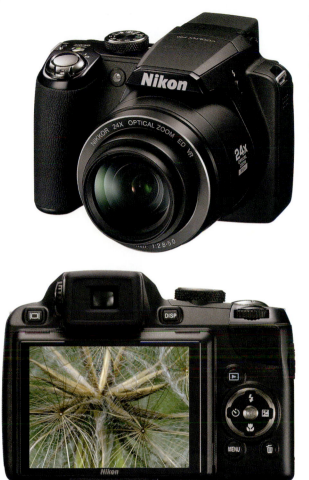

FIGURE 2.3 Nikon P90, a typical prosumer or bridge camera with 12.1 Mp, bridging the gap between a compact and an interchangeable-lens SLR. This model has a 24× optical zoom lens, equivalent to 26–624 mm, focusing down to just 1 cm. The EVF can be rather coarse for critical focusing.

(0.5 in.) in some models. Most models have a range of accessories, including lenses that attach to the front of the main camera lens to increase its close-up capabilities (or extend the wide-angle and telephoto capabilities). One in particular, used by several insect photographers, is the Raynox series of close-up lenses.

Both compact and bridge cameras have imaging sensors smaller than DSLRs. For example, the Nikon Coolpix P80 bridge camera has a ⅔-in. sensor containing 10 Mp. The issue of depth of field and focal length will be discussed in more detail in Chapter 3, but in general, smaller sensors have a larger depth of field for a given image magnification. Therefore, the depth of field with this particular model will be much greater than with a DSLR. An aperture of f/5.6 may give the same depth of field on this size of sensor

as a DSLR with an APS-C-sized sensor using an aperture of f/11. The main drawback is that you will need to be much closer to the subject than the DSLR fitted with a macro lens.

Many models nowadays also have image stabilization features built into them, helping to improve image quality for handheld shots.

Having a sealed, noninterchangeable lens eliminates one of the problems of interchangeable-lens DSLRs—that of dust on the sensor.

Interchangeable-Lens DSLRs

The interchangeable-lens DSLR is by far the most versatile camera type for close-up and macro work, enabling the use of a wide range of focal-length lenses, extension tubes, bellows, and teleconverters. The camera body can also be attached to telescopes and microscopes for other photographic applications.

DSLRs use a focal plane shutter, similar to SLR film cameras, and there is virtually no delay, or lag, in their operation. Many models can shoot several frames per second, which is essential for sport or wildlife photography.

Essential features to look for in a DSLR to be used for close-up and macro photography include a depth-of-field preview button, mirror lock-up, PC socket (for connecting an external flash), and the ability to manually focus the lens. Many of the cheaper models lack some of these features.

DSLRs are available with a range of different sensor sizes, usually either the APS-C size (and variants) and the full-frame (35 mm) size. The Olympus Four-Thirds system is another standard size, similar to the APS size (see the Image Sensors section later in this chapter)

New features are appearing all the time, with automatic sensor cleaning and live view options being found on many current models. Several models have recently come on the market with a high-definition video recording capability.

Camera Features and Settings

There are many features and settings that you should be aware of when making a camera choice.

Quality

Digital cameras offer an extensive range of quality settings, using terms such as fine, best, good, and basic. (Unfortunately, the terms are not consistent from one manufacturer to another.) For most macro and close-up work, use the maximum quality setting; you can always make lower-resolution versions

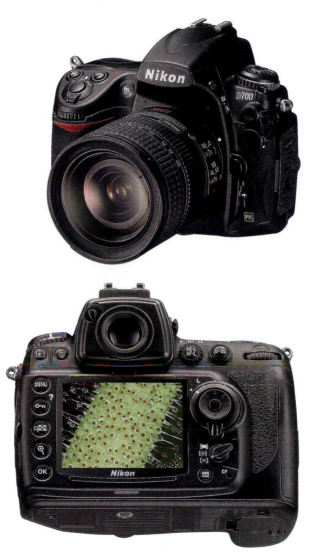

FIGURE 2.4 Nikon D700, a typical interchangeable-lens DSLR, with 12.1 Mp. This particular model also has facilities for high-definition video recording.

of your images for other purposes (such as Web display and digital projection) afterward if needed. Having the highest quality will also mean that you are able to crop the image if necessary.

Image File Formats

Most digital cameras offer the option of saving files in JPEG or RAW formats; some offer the option of saving a file with both of these formats at the same time. For various reasons, discussed later in Chapter 7, choose the RAW option

wherever possible. This gives the greatest control over image processing, both in terms of exposure and color balance.

Back Viewing Screen

All digital cameras have an LCD screen (or other type) on the back, showing a preview of the image, as well as other information such as camera settings and menus.

FIGURE 2.5 The back viewing screen from a Nikon D300, showing the captured image, histogram, exposure, and other technical details, as well as the date and time at which the image was exposed.

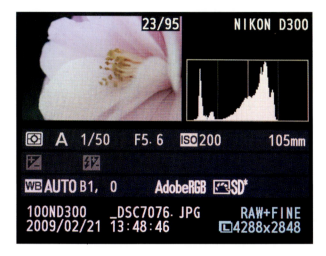

One particularly important item that can be displayed is the image histogram, which can be overlaid or viewed alongside the exposed image immediately after the shot is taken. Examination of this histogram can show if the image is under- or overexposed, or if shadows or highlights have detail. A full examination of the histogram is given in Chapter 7. Another facility related to this is the highlight flashing setting, where overexposed areas of highlight lacking any detail flash on and off. Some models have a similar facility for shadows as well.

New-generation DSLR models such as the Nikon D300 have a live view option, where a live image is shown on the back viewing screen. This may be useful when working in confined spaces, for example, particularly if the screen tilts and swivels, as with the Nikon D5000.

Viewfinders

Several accessories are available for DSLR viewfinders, which are of particular use to close-up photographers. An eyepiece magnifier is available for several camera models, enabling greater accuracy when manually focusing. Another

extremely valuable addition is the right-angle finder, which enables you to look through the viewfinder at an angle to it. It is particularly useful when photographing subjects at ground level, when you are able to look down into the camera rather than having to lie prostrate on the ground. It is also invaluable when using a vertical copy stand.

📖 **Dust**

A potential problem with interchangeable-lens DSLRs is that of dust. All the time the camera is switched on, a static charge is present on the surface of the image sensor. This attracts dust, which will show up on every single image taken with the camera, and in exactly the same place (unlike film where a speck of dust on one frame is wound on with the film). Always take great care and turn off the camera when changing lenses, choosing a dust-free environment if possible.

A quick test to see if you have dust on the sensor is to stop down the aperture to around f/11 or f/16, point the camera toward a pale overcast sky, and take a shot. Move the camera during the exposure. Any dust particles will show up as well-defined dark marks on the pale background.

If dust does appear on the sensor, most manufacturers offer a cleaning service. There are a large number of cleaning kits on the market, specifically for cleaning image sensors, from dry antistatic brushes to swabs and fluid. Cleaning sensors is outside the scope of this book, but a number of useful references are given in the Resources chapter. Only attempt to clean your sensor if you are fully confident that you know what you are doing; the sensor is by far the most expensive component in the camera.

Most new camera models nowadays have antidust facilities that vibrate the sensor to try to dislodge any dust particles.

Depth-of-Field Preview

Controlling depth of field is one of the most crucial elements of close-up photography, and the ability to preview it before exposing the shot is an extremely useful, if not essential, feature. A lever or button that stops down the lens to the aperture at which the image is going to be captured is present in many cameras, particularly top-end DSLRs. Although the image in the viewfinder will become darker as the lens is stopped down, it does, with practice, enable you to see distracting items in the background, brought into focus by stopping down the lens, or whether the depth of field is sufficient for the intended purpose of the shot.

Releasing the Shutter

Even though the camera might be mounted on a sturdy tripod, always use a remote release where possible. This minimizes the possibility of vibration to the camera at the time of exposure. The slightest movement of the camera during the exposure will be obvious in the final image, particularly if it is being magnified.

When the shutter is activated on an SLR, the mirror inside the camera flips up out of the light path, enabling the light to reach the open shutter. This can cause vibration inside the camera. Several cameras are equipped with the facility of locking up the mirror out of the light path before the shutter is opened. The procedure is to press the shutter button once to raise the mirror, then wait a few seconds to allow any vibrations to die down before the shutter button is depressed again to expose the image. This, of course, means that the camera must be supported on a tripod, and that the subject doesn't move in the time between the mirror flipping up and the shutter opening.

An alternative to the mirror lock-up is to use the delayed-action facility on the camera. This is the setting that is often portrayed as enabling you to take your own picture, whereby you point the camera at a scene, start the delayed-action setting, then run into the shot before the shutter has opened. Its main advantage in close-up photography is that you are not touching the camera at the time of exposure, minimizing the risk of vibration again. I most frequently use a combination of remote release and mirror lock-up to ensure the camera is perfectly still at the moment of exposure.

Exposure Modes

Most digital cameras offer at least four exposure modes: aperture priority, shutter priority, manual, and program, as well as various scene modes in some cases. The most appropriate one to use will depend on a number of factors, such as how much depth of field is required, or whether the subject is moving.

Aperture priority is probably the most useful mode when working in the field, where control of depth of field is essential. You set an aperture appropriate to the depth of field required, and the camera will automatically set the correct shutter speed to correctly expose the image. There will be occasions when the subject is moving (such as a plant moving in a breeze) or when you have to handhold the camera, when shutter priority is necessary to freeze the movement of the subject.

Shutter priority is when you select the shutter speed required to freeze the movement, and the camera automatically sets the corresponding aperture.

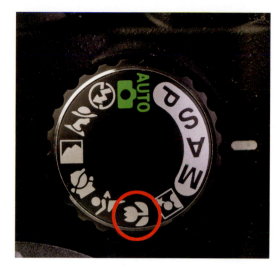

FIGURE 2.6 The mode dial from a Nikon D40, with the macro scene mode outlined. Notice the aperture (A) and shutter priority (S) settings.

I use the aperture priority mode for the vast majority of my close-up and general photography.

Manual mode is necessary when working indoors with flash, where you will need to be able to select both shutter speed and aperture independent of each other.

Program mode is basically a fully automatic mode, where you have no control over shutter speed, aperture, or, in some cases, even ISO. While you are virtually guaranteed a correctly exposed image, it may not have the required depth of field, or a shutter speed fast enough to freeze a moving subject.

Exposure compensation is used when working with subjects that are predominantly dark or light. This facility allows you to adjust the exposure usually in one-third stop increments either above or below the camera's metered exposure. For example, a white flower against a pale background might require up to one stop less exposure than the metered exposure reading, while a dark subject on a dark background might require more exposure.

One of the great advantages of digital photography is the ability to view the histogram of the image immediately after exposure, showing if either highlights or shadows are losing detail.

It must be remembered that cameras are not intelligent, and therefore do not know what you are trying to achieve, so one of the skills of the photographer is to choose the right combination of shutter speed and aperture to achieve the wanted image. Very often a compromise has to be made if the light levels are low or the subject is moving.

FIGURE 2.7 The exposure compensation button found on most digital cameras.

Scene Modes

Compact, bridge, and low-end DSLR cameras have a range of scene modes, one of which will be macro, indicated by the flower icon. This mode combines a medium aperture with a faster shutter speed to avoid camera shake. It does not allow control over the exposure though, and is not recommended for serious work.

ISO

The third component of the exposure system after shutter speed and aperture is that of sensor sensitivity. The ISO setting is the effective sensitivity of the imaging sensor, and works in the same way as film speed: A high ISO is more sensitive to light than a low ISO and requires less light to make a correct exposure. You may need to increase the ISO rating in order to achieve a specific shutter speed or aperture. In general, the best overall quality will be obtained with the ISO on its lowest setting (usually 100 or 200 ISO). As ISO is increased there may be an increase in "noise" in the image, giving shadow areas in particular a grainy appearance. The detrimental effects of noise have been greatly reduced over the last few years, and most good digital cameras can now be used at 800 ISO or more with little or no discernible noise.

Exposure Metering

There are several ways in which the internal camera meter measures the amount of light reflected from a subject, the three most common being spot, center-weighted, and matrix (evaluative) metering.

Spot (or partial) metering measures the light from a small area of the image (usually in the region of a 3-mm spot, 2–3 percent of the frame area). This can be very useful if the main subject occupies only a small part of the frame, such as a flower against a black background, but is not recommended for most general work.

FIGURE 2.8 When the main subject occupies only a small part of the frame, spot metering might be the most appropriate method of assessing exposure.

Center-weighted metering measures light from the whole frame, but gives priority to the center of the frame. In some cameras the size of the central area can be altered.

FIGURE 2.9 Center-weighted metering assesses exposure from the whole image, but gives priority to the central area of the frame.

Matrix (evaluative or honeycomb) metering basically splits up the scene into a matrix of metering zones that are evaluated individually. The overall final exposure is based on an algorithm specific to that camera, which takes into account focus point, subject size, lighting level, etc., and compares these with measurements in a database of typical scenes. This is perhaps the most useful metering system, and one that I use for probably 95 percent of my work when on location, finding it remarkably accurate.

FIGURE 2.10 Matrix or evaluative metering assesses exposure from a grid or matrix of sensors. This is the best mode for most subjects.

Vibration Reduction (Image Stabilization)

An increasing number of lenses (including the Nikon 105 mm Micro-Nikkor VR) and camera bodies have image stabilization or vibration-reduction facilities built into them. Manufacturers claim that this facility enables you to handhold the camera at much lower shutter speeds to get sharp images. With close-up and macro imaging this facility may be of use when stalking insects in the field, for example, but for most other subjects, to ensure consistently sharp images, a tripod or other form of camera support is highly recommended. It is very important to note that if you are using a tripod or other form of rigid camera support, manufacturers usually advise that you

turn off the vibration-reduction facility. Otherwise, the system is fighting against a solid object, and may actually introduce vibration into the image.

Through-the-Lens Flash

While many digital cameras have built-in flash units, the quality of light they give will invariably be inappropriate, because the flash is very close to the lens axis, causing flat lighting. An external flash of which the position can be altered will be a valuable accessory for close-up photography. When using external flash units, most DSLRs and bridge models have through-the-lens (TTL) flash capability, where the camera meter measures the amount of light that passes through the lens and reaches the sensor, and cuts it off when a sufficient amount has been received. You will need a dedicated flash gun to make use of this, either the manufacturers' own model or a third-party model. This facility will be examined in more detail in Chapter 5.

White Balance

Different light sources vary in their color (color temperature), and some, such as daylight or tungsten, can vary according to the time of day and weather, or the amount of voltage applied to them. This can cause color casts on images.

All digital cameras have a white balance facility, either automatic (AWB) or presets for specific light sources such as fluorescent, sunny, or cloudy daylight. In most cases the AWB will give excellent results, but if you are shooting with unusual light sources (e.g., fiber optic) or a mixture of different light sources, then it may be worth doing a white balance setup on the camera. Point the camera at a white or neutral piece of card (such as a photographic 18 percent gray card) and use the white balance facility of the camera to measure the color of the light source. It is essential that the card is receiving the same light as the subject (see Figures 5.4(a)–(c) in Chapter 5).

Memory Cards

There are many types of memory cards available for digital cameras, including Compact Flash, XD, and SD. Their capacity has increased greatly over the last few years—you can now get Compact Flash cards with a capacity of 32 gigabytes (Gb), for example. Personally, I only use cards with a maximum capacity of 4 Gb. If I lose a card, or one fails, I would rather lose 4 Gb of data than 32 Gb! Download your images as soon as you finish your shoot, and make a backup copy as well.

If you are working away from home, with no access to a computer, it may be worth getting a portable storage device, such as the Epson P3000, for downloading your images. Some of these have LCD screens for viewing, and

Tip
If you use your PC to delete the images from the card, make sure that you reformat the card every time you reuse it; similarly, if you switch cards from one camera to another. This will remove any data associated with the previous images, and minimize the risk of data corruption.

possibly editing, while on location. Some models also have built-in CD writers to give an extra level of backup.

Digital Backs

Over the last few years, as photography has gradually adopted the use of digital sensors, many digital backs have been marketed. These attach onto camera bodies in the same way that film holders do. Current models include the Hasselblad CF22 and CF39, containing 22 Mp and 39 Mp, respectively, and the 22-Mp Mamiya ZD. They are very expensive, but yield superb quality, being designed primarily for advertising and fashion photography. They are more than capable of close-up and macro photography, and use the same optical principles as DSLRs, albeit with larger sensors.

Image Sensors

In digital cameras, light-sensitive film is replaced by light-sensitive silicon chips, called image sensors. When choosing a DSLR, you can choose between different sizes of sensor, which will affect the final size of reproduction you can make, the quality of the image, and the lenses that you can use.

There are two basic types of image sensor in modern digital cameras, with a number of variations: the charge-coupled device (CCD) and the complementary metal oxide semiconductor (CMOS). For the purposes of close-up and macro photography the two types function in virtually the same way, and will give similar quality. The surface of the sensor is divided into a grid of light-sensitive photo sites called picture elements or pixels, which act like light meters, measuring the intensity of light falling on them. A voltage is generated from each pixel in proportion to the amount of light falling on it. This voltage is converted into digital data by an analog-to-digital converter (ADC) in the camera and then stored on the camera's memory card.

To capture color, each pixel is coated with a transparent red, green, or blue filter in a specific pattern known as a Bayer pattern. In a group of four pixels, there is one red-filtered and one blue-filtered pixel and two green-filtered ones, matching the way in which the human eye perceives color (human vision is most sensitive to green light). The resulting color for each pixel is determined by the values of those pixels surrounding it.

(a)

(b)

FIGURE 2.12 (a) Bayer pattern of colored filters on a grid of pixels. Note that there are twice as many green-filtered pixels as red- or blue-filtered ones. (b) The final value of each pixel is derived from a balance of itself and the value of those surrounding it.

There are a number of variations with different colored filters over the pixels, or, in the case of Super CCD sensors used in Fuji cameras, where there are two pixels at each sensing site—a large one for recording shadow detail and a smaller one for recording highlight detail. In this case, the pixels are octagonal rather than square, enabling a greater surface area per pixel.

Another type, the Foveon sensor, currently only used in Sigma digital cameras, has three sensor layers that measure the three primary colors. With a conventional CCD or CMOS sensor, only one-third of the pixels record red information, for example, while in a Foveon sensor, all pixel sites record red, green, and blue light.

Resolution and Sensor Size

All of the digital camera types are available with a number of different pixel resolutions, mostly in the range from 8 to 14 Mp, though several cameras are now available that have over 20 Mp. How many pixels you need will depend on a number of factors, primarily how large you intend to reproduce the images. In general, the more pixels you have, the better the image quality will be, though there are a lot of other factors involved such as the quality of the lens used and any in-camera image processing. The image from a 6-Mp mobile phone will almost certainly not be as good as that taken with a 6-Mp camera with a high-quality lens and saved as a RAW or high-quality JPEG file.

For most purposes, 8 Mp is adequate, and will give a high-quality A3 ink-jet print. For high-quality reproduction in books and magazines (photomechanical reproduction), 10 Mp, 12 Mp, or more may be required, and are becoming the norm in DSLRs. Table 2.1 gives examples of reproduction sizes with various sensor resolutions. Larger sensors will obviously offer greater opportunities for cropping parts of the image.

TABLE 2.1 Examples of pixel numbers and size of reproduction with ink-jet or photomechanical reproduction

Total Effective Pixels	Pixel Resolution	Ink-Jet Print at 240 dpi	Photomechanical Reproduction at 300 dpi
6 Mp	2816 × 2112	29.8 cm/11.7 in.	23.8 cm/9.3 in.
8 Mp	3264 × 2448	34.5 cm/13.5 in.	27.6 cm/10.8 in.
10 Mp	3648 × 2736	38.6 cm/15.2 in.	30.9 cm/12.1 in.
12 Mp	4000 × 3000	42.3 cm/16.6 in.	33.8 cm/13.3 in.

Note: dpi = dots per inch.

> ### Maximum Reproduction Size
>
> A simple rule of thumb to determine the maximum reproduction size of a digital image is to divide the largest dimension of pixels by the resolution of the printing device. Many high-quality magazines and books use a printing screen with a resolution of 150 lines per inch. The usual recommendation when producing images for this type of photomechanical reproduction is to set the image resolution to 300 dots per inch (dpi)—twice the resolution of the printing device. If you are using a 10-Mp sensor, this typically has dimensions of 3648 × 2736 pixels. If you divide 3648 by 300, this gives 12.1 in., easily good enough for a full-page magazine page.

Images can also be upsized, or interpolated, in image-processing programs, such as Adobe Photoshop (see Chapter 7), to enable larger reproduction sizes with minimal loss of quality.

The situation with sensor size can be quite confusing, however, whereby different sizes of sensors can have the same number of pixels, thus giving pixels of different sizes and densities. For example, the Nikon D300 camera has 12.3 Mp in a 23.6 × 15.8-mm DX sensor, while the Nikon D700 has 12.1 Mp in a 24 × 36-mm FX sensor. This will have an effect on the effective focal length of lenses, depth of field, and possible quality issues such as noise.

Compact and bridge cameras tend to have smaller sensors. For example, both the Nikon Coolpix S560 compact and the Nikon P80 bridge camera have a 10-Mp, $\frac{2}{3}$-in. sensor, with 3648 × 2736 pixels.

FIGURE 2.13 Diagram to show relative sizes of three imaging sensors.

Sensors in DSLRs with a "crop factor" of 1.5× or 1.6× are often given the generic name of APS-C (referring to the size of the APS film system), but there are several variants between manufacturers.

Effect of Sensor Size on Focal Length

Lenses can generally be divided into the broad categories of standard, wide-angle, and telephoto. The standard-length lens gives an angle of view similar to that of the human eye when viewing a scene in a fairly relaxed mode, without straining peripheral vision. With 35 mm film and digital cameras, the standard focal length of the lens is 50 mm, derived from the approximate length of the diagonal across the 24 × 36-mm film/sensor area. Wide-angle lenses have focal lengths shorter than 50 mm (e.g., 28 or 35 mm), while telephoto lenses have focal lengths longer than 50 mm (e.g., 100 or 200 mm).

Where a camera has a sensor smaller than 35 mm, the length of the diagonal is correspondingly shorter. The sensor in a Nikon D300, for example, is 23.6 × 15.8 mm. The length of the diagonal for this particular sensor is approximately 30 mm. Thus, a 30 mm lens used with this sensor would give an angle of view similar to a 50 mm lens on a 35 mm film sensor. Putting it another way, the 50 mm standard lens on a full-frame sensor would act as a telephoto lens on the smaller sensor. Thus, there is a magnifying, or "crop," factor of around 1.5× when lenses from 35 mm cameras are used with DSLRs with small sensors.

This can be very useful in some circumstances. For example, a 100 mm macro lens becomes effectively a 150 mm lens when used with an APS-C-sized sensor, allowing a greater working distance between camera and subject. A 300 mm lens becomes effectively a 450 mm lens, which is very useful for sport and wildlife photographers. The relative aperture remains unaffected—that is, an f/2.8 lens is still f/2.8 even though the effective length is longer. The main problem is with wide-angle lenses, where a 28 mm wide-angle lens becomes effectively a 42 mm lens, therefore no longer the wide-angle lens it was. You would need to use a 20 mm lens to give approximately the same angle of view as the 28 mm.

Most lens manufacturers now produce a range of lenses specifically designed for digital cameras with APS-C- and similar-sized sensors (e.g., Sigma DC, Nikon DX, Canon EF-S). They cannot be used with full-frame sensors as the circle they project is too small and severe vignetting will occur.

It is important that you know the size of the sensor in your camera; it will enable you to calculate the magnifying effect on the lens, and calculate precise magnification ratios, if this is important to you.

FIGURE 2.14 The difference between a full-frame (24 × 36 mm) sensor and an APS-sized sensor (23.6 × 15.8 mm). This gives a magnification, or "crop," factor of approximately 1.5×.

Scanners as Close-Up and Macro Cameras

Flatbed scanners are designed primarily for digitizing flat artwork or photographs, but can also be used to produce extremely high-quality close-up and macro images of three-dimensional objects, albeit with rather flat, noncontrollable lighting. While most scanners reflect light from the surface of solid objects, some have a "transparency hood" with a light source in the lid, which will pass through translucent objects.

For close-up and macro work, choose a standalone scanner with a lift-up lid rather than a multifunction device, and one with a transparency hood area as large as possible. You will need a higher resolution of up to 10,000 dpi or more if you are going to scan very small objects. (Despite using a CCD containing pixels, scan resolution is usually quoted in dots per inch, which is easily confused with printer resolution also being quoted in dots per inch.) The ability of a scanner to record the highest level of shadow detail and midrange gray values is its optical density. Choose one with as large a figure as possible.

FIGURE 2.15 A typical flatbed scanner, in this case scanning a three-dimensional object (a Roe Deer skull). This particular model has a transparency hood, allowing light to pass through transparent or translucent specimens.

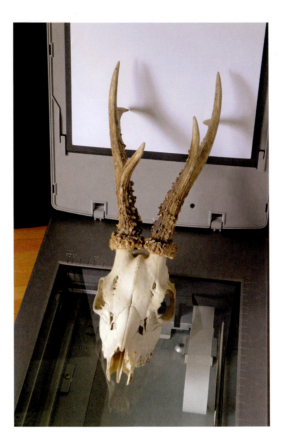

These typically range from around 3.2 D–3.4 D maximum in good consumer models to 4.0 D_{max} maximum in more expensive models.

A flatbed scanner has a scanning array consisting of a light source, mirror, lens, and CCD sensor containing a single line of pixels. This array is made to scan the selected area by a precision stepper motor controlled by the scanner software. Light is reflected from the surface of the object being scanned and recorded by the CCD sensor.

The quality of light given by the scanner is diffuse, similar to that given by a ring flash, but pleasantly soft. Some shadowing is produced when scanning subjects with a texture, caused by the scan head passing over the specimen in one direction, casting a shadow in its wake.

The scanner does have a certain depth of field when scanning three-dimensional objects, though this will vary somewhat according to the model and technology used in the scanner.

Reflected Light

When scanning, take great care not to scratch the surface of the glass when placing objects on the scanning plate. If you are scanning wet or damp objects it might be worthwhile to place a sheet of acetate over the glass to protect it.

The inside of the lid consists of a spongy white surface, which could easily become permanently dented if laid onto a solid object. Instead, if a white background is required, try leaving the lid open, and rest or suspend a sheet of white card over the object. Leaving the lid partially open, perhaps to accommodate a large specimen, will give a gray background.

To obtain a black background, just leave the scanner lid open. The light has nothing to reflect from other than the specimen, so this will produce a very deep black background.

Transparent/Translucent Specimens

For scanners with a transparency hood, the white sheet inside the lid usually lifts out to reveal the fluorescent light source. This is usually much smaller than the main area of the scanner—most are in the region of 5-in. wide. The light from the lid passes through transparent or translucent subjects such as leaves. Not all subjects work well, particularly if they are too thick, and some experimentation will be required. It is even worth trying to scan microscope slides. If the specimen on the slide is large enough, very acceptable images can be obtained.

Double Scanning

One technique to try is to scan the object twice, one with reflected light, then again with the transparency hood. You will end up with two images that can be combined in Adobe Photoshop. Using the facilities in the "layers" dialog box, you can differentially adjust the density of the two images when blending them to produce the desired effect. Note that you will need to tape the subject to the glass to ensure that the two scans are of identical areas.

Film Scanners

Another type of scanner is designed specifically for scanning film transparencies and negatives. While several models feature motorized film holders, others allow you to slip a transparency mount manually into the film holder. This may allow you to insert a glass microscope slide. If the specimen on the slide is large enough, remarkably detailed images can be obtained from these slides. A high scan resolution may be required.

Scanner Operation

The practical operation of the scanner is very simple, with all controls being found in the scan control panel (the TWAIN driver).

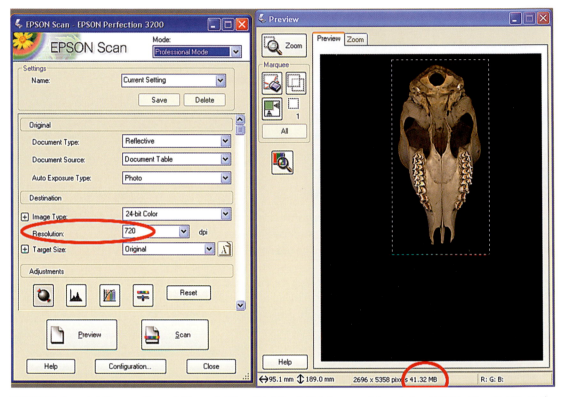

FIGURE 2.16 Screenshot of scanner software. In this case the 18-cm (7-in.) deer skull is being scanned at a resolution of 720 dpi, giving a final file size of 41.32 Mb. Note the crop section around the skull. The lid was left open, giving a black background.

First, make a preview, or prescan. This gives a low-resolution preview that can be cropped to give the active scanning area. Don't scan anything you don't need to. This allows you to select reflective or transmission modes, resolution, and grayscale or color scanning. If your software has an "unsharp mask" option, turn it off—it is often on by default. It is much better to apply the sharpening after any image resizing.

Because the objects to be scanned will vary in size, it is probably best to set the resolution to give a final image size (e.g., 12 Mb), 25 Mb, etc.). As a rule of thumb, 12 Mb is sufficient to give a high-quality A4 ink-jet print, 25 Mb for an A3 print, while a 48-Mb file is the accepted norm for picture libraries and publication.

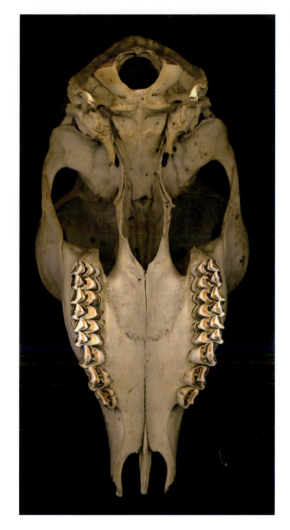

FIGURE 2.17 The resulting scan of the deer skull from Figure 2.16.

FIGURE 2.18 (a) The extraordinary detail recorded by the scanner is shown in this image of the underside of a bracket fungus. The whole specimen was 120 mm (4.5 in.) across. (b) This section was scanned at 6400 dpi.

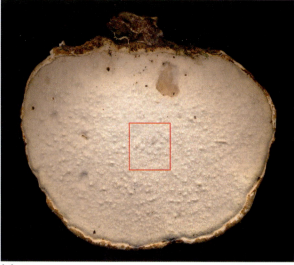

(a)

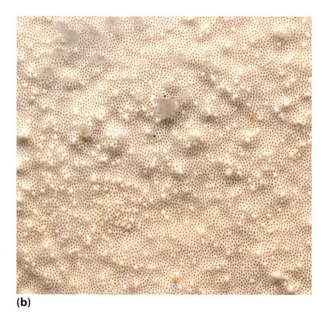

(b)

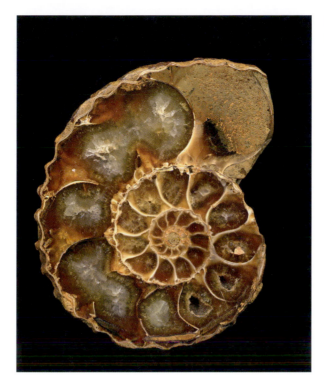

FIGURE 2.19 This polished section through a fossil ammonite made an excellent specimen for the flatbed scanner.

FIGURE 2.20 Shutting the lid partially gives various shades of background tone for (a) a fritillary and (b) a toadstool.

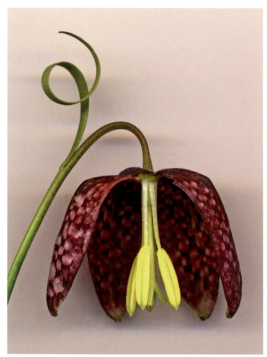

(a)

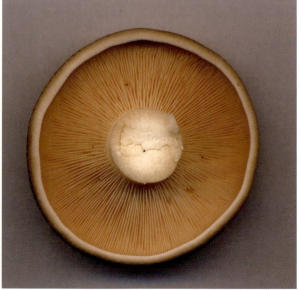

(b)

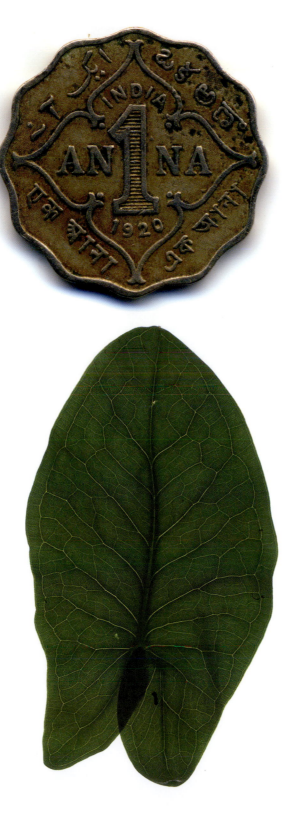

FIGURE 2.21 Flat objects such as coins can be scanned with the lid completely closed, giving a pure-white background. If the coin is orientated in the right direction in relation to the scanner head and light source, the shadow appears underneath the specimen.

FIGURE 2.22 Translucent subjects such as leaves can be scanned in "transparency" mode, so the light passes through the object. This is the leaf of a Cuckoo Pint (*Arum maculatum*).

FIGURE 2.23 Scan through a bramble leaf showing autumn colors.

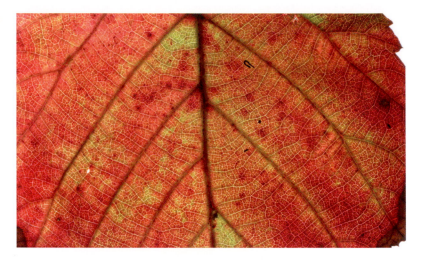

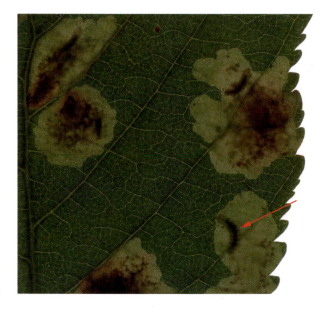

FIGURE 2.24 Scan through a Horse Chestnut leaf showing larvae of the leaf miner moth (Cameraria ohridella).

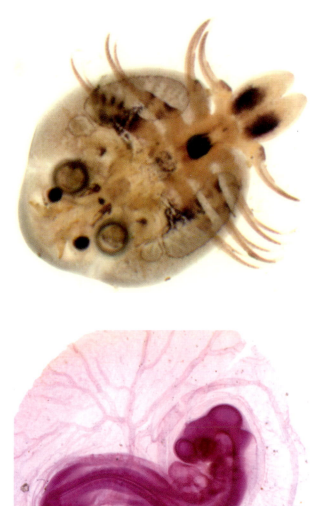

Parasitic fish louse (Argulus) scanned from a 150-year-old Victorian microscope slide at 6400 dpi.

FIGURE 2.26 A 72-hour chicken embryo scanned from a microscope slide. The length of the specimen is approximately 5 mm.

Image Enhancement

Images obtained by scanning may be relatively low contrast and will benefit from levels or curves adjustment in an image-processing program such as Adobe Photoshop (see Chapter 7).

Lenses

When working with DSLRs, virtually any lens can be used for close-up and macro photography with the appropriate accessories, though some will certainly give better results than others, often being designed specifically for the purpose. Different focal-length lenses will determine the distance you are from your subject, and the angle of view—that is, how much of the background will appear in the final image. Photographing most insects, for example, will require a medium to long telephoto lens, to ensure a good working distance and to avoid disturbing them. Doubling the focal length of the lens doubles the working distance, so a 100 mm macro lens will be twice the distance from the subject for a given magnification as a 50 mm lens. A telephoto lens in the region of 200–300 mm will be very useful for isolating a small plant from its possibly distracting background.

Many lenses have a close focus facility, which is not the same as having true macro capability or performance. A true macro lens is designed to give its best performance when used close to a subject. A lens with a close focus facility may not be as sharp when used close up as it is with "normal" photography. You will need to test your own lenses to see how they perform under certain conditions.

FIGURE 3.1 A relatively long focal-length lens (200 mm) together with a wide aperture was used to isolate this group of Dicentra flowers from their background. Camera: Nikon D300, Nikon 70–20 mm f/2.8 lens, $\frac{1}{60}$ sec. at f/5.6.

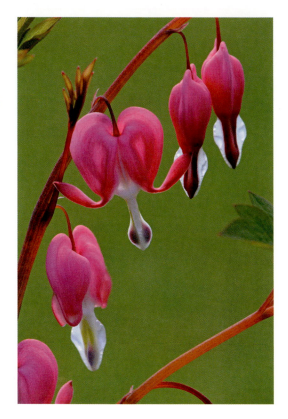

It is also well worth experimenting with different types of lenses. Lenses from photographic enlargers (often available cheaply secondhand nowadays), for example, can make excellent macro lenses, as can lenses from old cine cameras. Adapter rings to fit them on to the various camera mounts are available from the companies listed in the Resources chapter.

All the major lens manufacturers are now producing "digital" lenses—that is, lenses optimized to give their best performance when used with digital rather than film cameras. Companies such as Tamron and Sigma have digital macro lenses. A word of caution: If you buy a lens designed for an APS-size sensor, then at some time in the future decide to upgrade to a full-frame camera, you will need to upgrade the lens as well.

Focal Length and Sensor Size

The focal length inscribed on a lens assumes that the lens will be used on a camera body with a 35 mm–size sensor (or film); this applies even to the

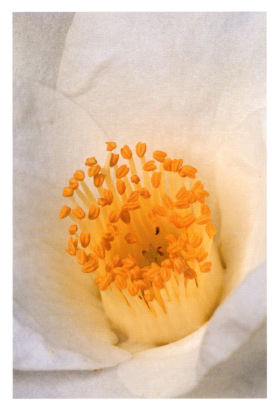

FIGURE 3.2 A high-quality macro lens was used to record the fine detail in these Camellia stamens. Camera: Nikon D300, 105 mm Micro-Nikkor, ⅟₁₅ sec. at f/16.

lenses designed specifically for smaller sensors. Currently, although there are an increasing number of cameras on the market containing a full-frame sensor, they are in the minority, and most DSLRs have sensors smaller than the 35 mm frame. A lens designed for a 35 mm–size sensor will project a circular image just larger than the sensor. If the sensor is smaller than 35 mm, then the circle is too large, and only the central portion of the projected image is used (which is usually the area of the lens giving the best results). This effectively magnifies the quoted focal length of the lens, usually by around 1.5× or 1.6×. This is sometimes referred to as the "crop factor." Thus, a 100 mm focal-length lens, when used on a DSLR with an APS-C-size sensor, will have an effective focal length of 150 mm; a 200 mm becomes effectively 300 mm, etc. For the purposes of this book, the focal lengths quoted will be the figure quoted on the lens (i.e., the 35 mm equivalent). This will need to be multiplied by the crop factor of your particular camera model if you are not using a full-frame sensor. The exact figure will be found in the technical specifications section of your camera manual.

Focusing

When shooting close-up or macro images, rotating the focusing ring on the lens will have little or no effect. The best method is to set the lens for a specific magnification, and then move the whole camera and lens combination backwards and forwards to the subject to bring the image into focus. Special focusing rails are available for this, enabling very fine control; they are discussed further in Chapter 4.

Autofocus

Most lenses and cameras nowadays have an autofocus (AF) capability (some less-expensive cameras do not offer the option of turning it off), which is one of the great innovations for "conventional" photography. For macro photography, however, it is less useful, and may even lead to incorrect focusing. In the camera viewfinder are a number of AF points or zones, from 4 or 5 to 50 or more in high-end cameras. When one of these points is selected, that is the region of the image that the lens will focus on. If, however, the most important part of the subject is smaller than that zone, or cannot be distinguished by the camera (e.g., a strand of a spider's web) then the lens may not focus correctly, and constantly "hunt" for the correct focus. For that reason it is essential that any camera system you choose for close-up photography has a manual focus facility, so you can focus precisely on the most important area of the subject.

Close-Up Supplementary Lenses

While different lenses vary in their close-up focus capability, if you want to produce high magnifications you will almost certainly need some sort of accessory to enable the lens to focus closer. Probably the simplest, quickest, and possibly cheapest route to close-up photography is to use close-up, or supplementary, lenses (sometimes known simply as *diopters*), which screw onto the front of a camera lens, enabling it to focus closer than it normally would. (For noninterchangeable-lens compact and bridge cameras, this will be the only way of increasing image magnification.) Their big advantage over extension tubes or bellows is that they do not reduce the amount of light reaching the sensor, and thus require no exposure compensation. Two (or more) close-up lenses can be used in combination to increase the effect, though quality may be reduced.

Only one or two manufacturers now make close-up lenses, and while it is possible to buy relatively cheap, single-element close-up lenses, it is definitely worth investing in high-quality models. Putting a $15 lens onto a $750 lens will probably not yield the best results! Some supplementary

lenses are actually matched to specific lenses. Autofocusing may be affected, and manual focusing is strongly recommended. Canon manufacture lenses with two different strengths, in a range of diameters. They are constructed of two lens elements (achromatic) to reduce color aberrations, giving very high quality. The 250D model gives a closest focusing distance of 250 mm (10 in.) when the lens is set to infinity, and is aimed at lenses in the region of 38–135 mm focal length. The 500D version focuses to 500 mm (20 in.) and is designed for lenses in the region of 75–300 mm. Other current manufacturers of close-up lenses include Hoya and Raynox. Sadly, Nikon have discontinued their line of close-up lenses. Even with a high-quality close-up lens it is probably worth stopping down the lens by two to three stops to ensure the sharpest results.

Strength

Close-up lenses are available in different strengths, either rated in diopters, such as +1, +2, or +3, or a figure indicating their closest focusing distance. With the diopter scale, the higher the number, the greater the magnification provided. They can be used in combination, so that a +1 and +2 become a +3 diopter.

Magnification through Extension

Probably the best way of achieving greater image magnification with an interchangeable-lens DSLR is to extend the distance between the lens and the camera body: The greater the extension, the greater the magnification obtained. A simple formula can be used to determine the extension required for a particular magnification:

$$\text{Lens} - \text{Sensor Distance}\,(V) = \text{Focal Length}\,(M+1)$$

where V stands for lens to sensor distance and M stands for magnification. For example, for a magnification of 1×, a 50 mm lens will require a 100 mm (4 in.) extension:

$$V = 50\,(1+1)$$

That is, 100 mm. A 100 mm lens will require a 200 mm (8 in.) extension to achieve the same magnification.

This extension can be achieved either through the use of rigid extension tubes or flexible extension bellows. Specialist macro lenses such as the Nikon Micro-Nikkor 105 mm and the Canon 100 mm macro lenses have sufficient extension built into the barrel of the lens to achieve a magnification of 1× without the need for further extension.

Extension Tubes

Extension tubes are rigid, hollow tubes that extend the distance between the lens and image sensor. They are available in different lengths, and can be used in combination to achieve greater extension. Most of the tubes available retain the linkage from camera body to lens aperture, though not all retain the autofocus ability of the lens (though, as previously discussed, this will not be a problem for the vast majority of macro work).

Extension Bellows

Extension bellows allow you to finely adjust the length of the extension, allowing much greater flexibility than fixed-length tubes. Most systems do not retain the aperture linkage though, and require the use of a double-cable release system to allow semi-automatic aperture control. Bellows are cumbersome to use in the field and are generally better suited to studio work.

Some bellow units, such as the Novoflex Balpro system and the discontinued Nikon PB4 unit, offer the facility of tilting and shifting the lens, allowing you to maximize depth of field using Scheimpflug principles, similar to large-format cameras (see the Perspective Control (Tilt and Shift) Lenses section later in this chapter).

FIGURE 3.3 Novoflex Twin rail bellows. The bottom rail is a focusing rail.

Exposure Compensation with Tubes and Bellows

Using bellows or extension tubes means that the light has to travel further through the system before it reaches the image sensor. If you are not using TTL metering, perhaps using flash in the studio and assessing exposure with a separate flash meter, then some allowance will need to be made for the reduced amount of light reaching the sensor.

A formula used to calculate the compensation factor required is:

$$\text{Compensation Factor} = \text{Metered Exposure} \, (M+1)^2$$

For example, for a magnification of 1×:

$$\text{Compensation Factor} = \text{Metered Exposure} \times (1+1)^2 = 4$$

This factor means that four times more light is required to give the correct exposure (i.e., two stops). A metered exposure of f/16 would become f/8, for example.

Of course, with digital cameras, and their ability to display the exposed image and its associated histogram on the back screen, it is easy to adjust the aperture until you achieve the right exposure, and there is little need for such calculations nowadays.

Reversing Lenses

For most photography, the lens-to-subject distance is greater than the lens-to-sensor distance, and most lenses, because they are not symmetrical, are designed to give their best performance in this configuration. However, with close-up and macro photography, depending on the lens and magnification being used, the lens-to-sensor distance may exceed the lens-to-subject distance. Better performance may be gained by reversing the lens onto bellows or extension tubes with a special reversing ring (available from the suppliers listed in the Resources chapter), restoring the configuration for which they are designed. Some manufacturers even recommend that some of their macro lenses perform better in a reversed position when used for magnifications greater than 1×. The mechanical and electronic linkages between the lens and camera are lost, however, and in practice, this technique is limited to studio applications.

The rear element of the lens (now aimed at the subject) often stands proud of the lens assembly and may be prone to flare. A useful lens hood can be improvised with an extension tube of an appropriate length. Check for vignetting, and switch to a shorter tube if it is seen in the corners of the image.

FIGURE 3.4 A Nikon 55 mm Micro-Nikkor manual-focus lens, reversed onto a Nikon bellows unit.

FIGURE 3.5 An extension tube used as a lens hood to help reduce flare.

Macro Lenses

All the major camera and lens manufacturers make specialist macro lenses (as opposed to lenses with a close-focus facility), which are designed to give their best performance when used close to a subject (though they will also give excellent results when used for "normal" photography as well). They are generally available in three focal lengths: standard (e.g., 55 mm and 60 mm), short telephoto (e.g., 90 mm and 105 mm), and telephoto (e.g., 200 mm), as well as zooms such as the Micro-Nikkor 70–180 mm. Many have a sufficient built-in extension to give a life-size magnification.

A large number of specialist macro lenses have been available over the years, particularly short-focus lenses to be attached to the end of bellows units. They often can be found secondhand, and can give superb results. Nikon used to make a 105 mm f/4 short-mount lens that was mounted onto a bellows unit; it is much sought after nowadays. I have an ancient Leitz Summar 12 cm lens that I attach to a Nikon bellows via an adapter, and it gives outstanding images.

Canon MP-E65 Macro Lens

This unique lens is a manual-focus macro lens, designed only for magnifications between 1× and 5×, without the use of any additional accessories. It achieves this remarkable range by having a built-in extendable extension tube. It is a difficult lens to master—at 1× it is 100 mm (4 in.) away from the subject and at 5× it is just 40 mm (1.6 in.) away, leaving little room for creative lighting. The lens extends from around 100 mm (4 in.) at 1× to around 230 mm (9 in.) at 5×. There is no focusing ring; to use the lens you need to preset the magnification required, then move the whole camera/lens assembly until focus is achieved. This will probably require some sort of focusing rail to achieve the minute movement required. The lens can even be used for some specimens mounted as microscope slides.

Depth of field (DOF) at these high magnifications is very small, and will be discussed later in this chapter, but a couple of examples are shown here to illustrate the problem:

1×:	f/2.8: DOF: 0.4 mm
	f/16: DOF: 2.24 mm
5×:	f/2.8: DOF: 0.048 mm
	f/16: DOF: 0.27 mm

As will be discussed later, it would not be a good idea to stop down the lens to f/16 at a magnification of 5×, as the image quality would suffer from the effects of diffraction.

FIGURE 3.6 The Canon MP-E65 macro lens, at full extension to give a magnification of 5×. Note the heavy-duty Arca Swiss ball-and-socket head on the tripod.

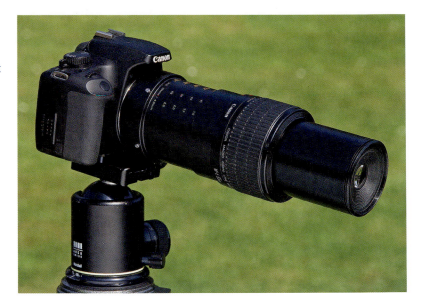

FIGURE 3.7 The tip of a dentist's drill, shot at 5× magnification using two fiber optic lights, with the Canon MP-E65 lens.

FIGURE 3.8 A microscope slide with a stained cross section through a one-year-old twig from a fir tree, shot at 5× magnification. This image and Figure 3.9 were shot using a photographic light box. Camera: Canon 1000D, MP-E65 macro lens, $\frac{1}{15}$ sec. at f/5.6.

FIGURE 3.9 A stained section through a Dandelion flower. Camera: Nikon D300, 200 mm lens with a 28 mm lens "stacked" in front; magnification approximately 4×.

Wide-Angle Lens

Wide-angle lenses can be used to give highly creative close-up images, but they can be difficult to use. For example, a 28 mm lens will be just 3.5 cm (1.5 in.) away from the subject at a magnification of $\frac{1}{4}$×, requiring very precise positioning of the camera. However, the wide angle of view does mean that you will include much more of the background in the image, showing a plant in its habitat, for example.

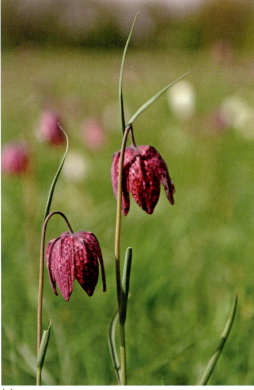 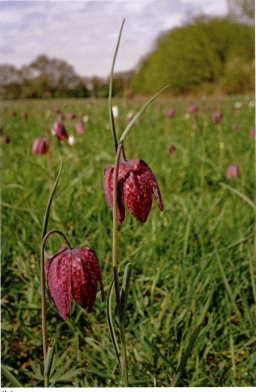

(a) (b)

FIGURE 3.10 Snake's Head Fritillaries—series of images showing the effect of different focal-length lenses. The camera was moved so that the size of the flowers remained constant (as far as was practical in the field), using the following lenses: (a) 20 mm, (b) 55 mm, and (c) 200 mm. Note the change in background, and how the wide-angle lens shows the flowers in their habitat. Camera: Nikon D300, 20, 55, and 200 mm lenses.

Standard Lens

A standard lens is the one that most closely matches the human eye in terms of field of view. For a full-frame sensor it will be 50 mm focal length, while for an APS-C-size sensor it will be in the region of 35 mm. Most lens manufacturers make standard-length macro lenses, such as the Nikon 60 mm Micro-Nikkor.

Telephoto Lens

It might be thought that long telephoto lenses would have little use for close-up and macro photography, but in fact they can be extremely useful for photographing inaccessible subjects, or keeping a reasonable distance from a nervous subject such as a dragonfly. Many telephoto lenses will focus

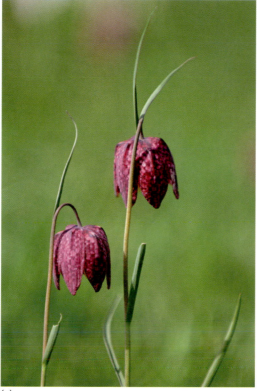

FIGURE 3.10 *Continued*

(c)

reasonably close without any extra accessories, but they can be used in conjunction with close-up supplementary lenses or extension tubes to enable them to focus closer to the subject. Many insect photographers routinely use focal lengths of 200 mm or more to give a good working distance from the subject, while plant photographers use long lenses to isolate flowers from their backgrounds, for example.

Zoom Lens

A zoom lens, or variable focal-length lens, encompasses a range of focal lengths within it. Typical zoom lenses ranges are 35–70, 70–200, and 200–400 mm. They are sometimes referred to by their zoom range—for example, a 70–210 mm lens is a 3× zoom. Modern zooms now have ranges up to 10×, such as a 28–300 mm. Many zooms have a macro setting that offers magnification of $\frac{1}{2}$× or even 1×, depending on the model, though the macro setting may only be possible at one particular focal length within the range.

FIGURE 3.11 I used a 10 mm wide-angle lens to show this young fern in its bluebell wood habitat. The front of the lens was only around 10 cm (4 in.) from the fern. Camera: Nikon D300, Sigma 10–20 mm lens set to 10 mm, $\frac{1}{10}$ sec. at f/11.

Teleconverters

Teleconverters (or extenders) are optical devices that fit between the lens and the camera body, and magnify the image from the lens by a specific amount. They are most often used by wildlife photographers, requiring longer focal-length lenses, but they do have a use in close-up and macro photography: They increase the focal length and thereby increase the working distance to the subject. They are available in various strengths: 1.4×, 1.7×, 2×, and 3×. A 300 mm lens, attached to a 1.4× converter, becomes effectively a 420 mm focal length, while a 200 mm lens attached to a 2× converter becomes effectively a 400 mm focal length. I often use a 1.4× converter with my 105 mm f/2.8 Micro-Nikkor VR lens, giving a combination of 150 mm f/4. This increases the working distance for a given magnification and increases the maximum magnification to 1.4×.

The amount of light reaching the sensor is reduced by the converter. A 1.4× converter reduces the amount of light by one stop, and a 2× converter reduces the amount of light by two stops. Thus, a 300 mm f/4 lens, when used

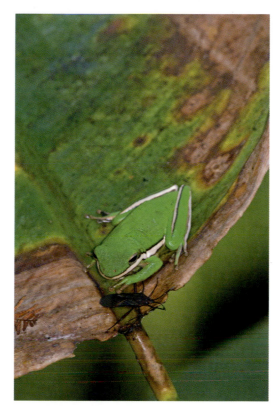

FIGURE 3.12 I spotted this tiny Green Treefrog *(Hyla cinerea)* with its potential bug prey about 30 feet away from the boardwalk at the Audobon Corkscrew Swamp Sanctuary in Naples, Florida. There was no way of getting closer to it, so I used a Nikon 300 mm f/4 lens with a 1.4× converter. This combination, added to the 1.5× magnifying factor of the sensor, gives the equivalent of a 630 mm lens, yet still focuses down to around 100 cm (3.5 ft). The camera was mounted on a sturdy carbon fiber tripod. The light was very poor, and since I didn't have a separate flash unit with me, I used the pop-up flash on the camera. Camera: Nikon D300, 300 mm lens with 1.4× converter, ⅟₆₀ sec. at f/11.

with a 1.4× converter, becomes effectively a 420 mm f/5.6 lens. It is well worth buying the converter from the same manufacturer as the lens with which you will use it since converters are very often matched to specific lenses. Cheaper models are available, but may give poor results.

As discussed earlier, increasing the focal length of the lens increases the working distance from camera to subject. For close-up and macro work, however, it is possible that the lens/converter combination will not focus close enough to the subject and there will be the need to use extension tubes (or close-up supplementary lenses) to achieve the required magnification. There are two ways of doing this. You can either place the extension tube behind the combined lens and converter, or you can put the extension tube behind the lens, then the converter behind that. Using the example of a 105 mm lens with a 1.4× converter and extension tube:

- *Option 1:* The 105 mm lens has an extension tube placed directly behind it, yielding a magnification of around ½×. The converter is placed behind this combination and multiplies the magnification, giving a final magnification of around ¾×.

- *Option 2:* The converter is placed directly behind the lens, producing an effective focal length of approximately 150 mm. An extension tube is then placed behind this combination, giving a final magnification of around $\frac{1}{3}\times$.

Take great care when experimenting with combinations like this, and read the manufacturers' instruction manuals carefully. Some extension tubes cannot be used with, or don't physically fit, some lenses or converters, and may damage the delicate linkages if forced into position.

When using this type of combination, check the corners of the image carefully for vignetting, which may result with increasing magnification.

Other Lens Types

While the discussion so far has dealt with conventional camera lenses, it is possible to use other types for close-up and macro photography, in particular those designed for use in enlargers. Because enlarger lenses are designed to work best close to their subject (i.e., the negative in the enlarger) they can make excellent macro lenses when attached to extension bellows.

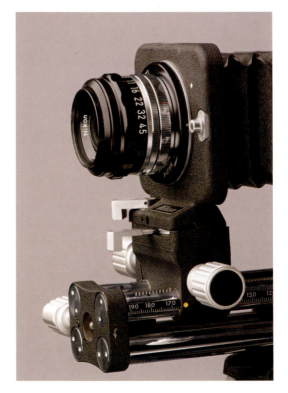

FIGURE 3.13 An old 75 mm El Nikkor enlarging lens mounted onto an old Nikon PB4 bellows unit using a Nikon/ Leica adaptor ring. (This particular model had a built-in tilt/shift facility.) Due to their optical construction, enlarging lenses generally make excellent macro lenses.

Most enlarger lenses have a 42 mm Leica-type screw thread, and adapters are available from specialist suppliers to convert this thread to camera bayonet fittings such as Canon and Nikon.

Other lenses to try would be those from old cine cameras, which usually have a "C"-mount screw thread, for which, again, adapters are available.

Perspective Control (Tilt and Shift) Lenses

These lenses were designed originally for architectural photography, to enable photographers to achieve control of perspective. The lens can be tilted in either a vertical or horizontal plane relative to the camera, or shifted up and down or sideways. These movements are similar to those found in large-format sheet film cameras used by studio and architectural photographers for increasing depth of field or correcting perspective distortions. The tilt movement can be used to increase depth of field within an image without stopping down the lens. The theory is based on the Scheimpflug Principle, which states that an image will have optimum sharpness when a plane through the lens panel, image sensor, and subject intersect at a common point.

Today, several models are available with macro capabilities, including the Nikon PC-E Nikkor 85 mm and the Canon TS-E90 mm. The amount of tilt and shift is rather limited, to prevent vignetting of the image, so it may not be possible to bring all of a subject into sharp focus using swing and tilt movements alone—you may still need to stop down the aperture as well.

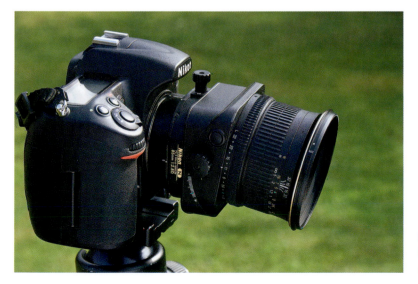

FIGURE 3.14 The Nikon 85 mm PC lens allows tilt and shift movements to maximize depth of field.

Another system, the Zork MFS, differs slightly from the models above in that it is basically a tilt tube, capable of much greater angles than the Nikon or Canon models. It is designed for use either with enlarging lenses, or lenses from medium- and large-format cameras.

FIGURE 3.15 (a) With the camera at an angle to the subject, depth of field will be restricted. (b) By swinging the lens planes through the imaging sensor, the lens and subject can be made to intersect, increasing depth of field. The amount of swing will be limited to prevent vignetting of the image, so it may not always be possible to bring the whole of a subject into sharp focus. Also, it is not always easy to exactly decide on the main subject plane. Having achieved the optimal position for the lens, the aperture can be used to further increase depth of field, and take into account other factors such as the height of a subject.

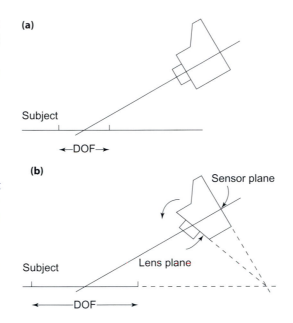

(a)

Subject

←DOF→

(b)

Sensor plane

Subject

Lens plane

←———DOF———→

Stacking Lenses

An alternative approach to using a supplementary close-up lens is to use another camera lens as the supplementary, "stacked" onto the prime lens. This technique was popular 20 years ago, but seldom used today, though it is well worth experimenting with, as high magnifications can be obtained relatively easily, often with excellent results.

The usual technique is to mount a medium telephoto lens (not a zoom, as their complex construction does not always give good quality in this case) on the camera body (e.g., a 200 mm lens), and then mount onto the front of it a reversed shorter focal-length lens (e.g., 50 mm). You will need a "coupling" ring, available from several manufacturers (see the Resources chapter), to enable you to join the two lenses together. A short extension tube can be improvised as a lens hood for the reversed lens.

The power (in diopters) of the reversed lens is 1000/focal length. Thus, a 50 mm lens will have a power of +20, and a 100 mm lens will have a power of +10. The magnification obtained with this combination is approximately:

$$M = \frac{\text{Focal length of primary lens}}{\text{Focal length of reversed lens}}$$

FIGURE 3.16 This antique exposure meter was photographed at an angle with the Nikon 85 mm PC lens at an aperture of f/4. By tilting the lens so that the planes through the subject, sensor, and lens coincide, the entire image was brought into sharp focus. Camera: Nikon D300, Nikon 85 mm PC lens, daylight, $\frac{1}{10}$ sec. at f/4.

FIGURE 3.17 Leaf of the insectivorous Sundew, (Drosera), photographed at an angle. The lens was tilted to bring most of it into focus at f/4. Camera: Nikon D300, Nikon 85 mm PC lens, diffuse flash, 1/60 sec. at f/4.

FIGURE 3.18 A 28 mm lens "stacked" onto a Nikon 200 mm lens. The combination gives a magnification of around 7× when both lenses are set to their infinity setting.

For example, if the primary lens is 200 mm, and the reversed lens is 50 mm, then the magnification will be approximately 4× with both lenses set to their infinity setting.

Keep the aperture wide open on the "front" lens, and control exposure with the aperture of the prime lens.

This combination is rather heavy and cumbersome, probably lending itself more to the studio rather than field work.

Depth of Field

Achieving sufficient depth of field while maintaining high image quality is one of the greatest problems for a close-up photographer. In general, in close-up and macro photography, depth of field is extremely small, fractions of a millimeter in some cases, and becomes increasingly smaller with increasing magnification. There will be many subjects where it is not possible to obtain sufficient depth of field to render the whole subject sharp. It is always worth asking yourself whether you actually need such a high magnification, or whether a smaller magnification, with its correspondingly greater depth of field, is a better compromise.

Always make sure to focus on the most important part of a subject (the eye of an insect, for example), and, if possible, align the main plane of the subject with the plane of the image sensor. This will ensure maximum possible depth of field, though may well lead to images that lack creativity.

Consideration of depth of field and its effect on both image content and quality can become highly technical, with complex formulas for calculating it based on esoteric factors such as the size of the acceptable circle of confusion. In the end, what really matters, of course, is the appearance of the final image, and you will need to do practical tests to see how your equipment performs for the sort of work you are doing.

Depth of field is dependent on the size of the sensor in the camera. A full-frame, 35 mm–size sensor will, for a given magnification, have a smaller depth of field than a smaller sensor. A sensor with a 1.5× crop factor will give depth of field values approximately 1.5× greater than the corresponding 35 mm–size sensor.

Definition

Depth of field can be defined as the distance between the furthest and nearest points of a subject that are acceptably sharp. When you focus

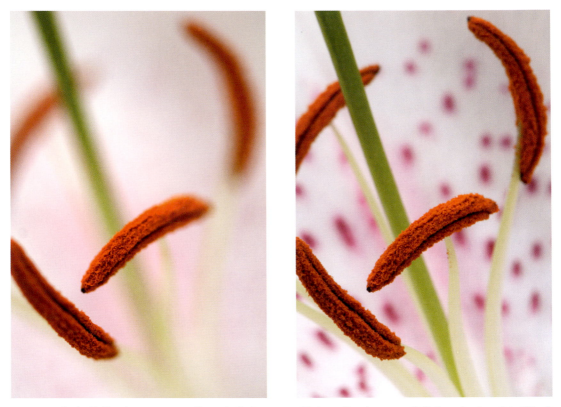

FIGURE 3.19 Depth of field can have an enormous effect on the final appearance of the image. Here, the stamens of a lily flower have been shot at f/4 and f/32 with a 105 mm macro lens. Camera: Nikon D300, 105 mm Micro-Nikkor.

on a particular point of a subject there is a zone of acceptable sharpness beyond which the subject detail is unsharp. In "normal" photography the zone of acceptable sharpness extends from one-third in front of the main point of focus, to two-thirds behind it. A good rule of thumb to maximize depth of field is to focus one-third into the subject. This is true for "normal" photography of distant subjects, but as the magnification of the subject increases, these relative proportions change. Therefore, at a magnification of 1×, the distances in front of and behind the main point of focus become equal, and you should focus on a point halfway into the subject.

The key word in the above definition is "acceptable," and this is obviously subjective—different photographers may well have different opinions as to what is acceptably sharp. Various formulas have been devised to calculate depth of field for different magnification/aperture combinations, and make use of the concept of "circles of confusion" to define sharpness, and take into account the assumed final size of reproduction.

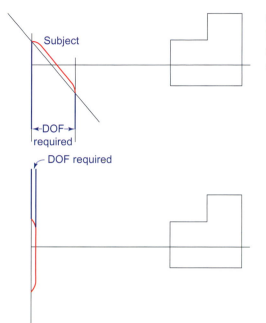

Depth of field is dependent on magnification and aperture, not focal length. If the same subject is photographed with a 50 mm lens and then a 200 mm lens, and the distance from the camera to the subject is altered so that the magnification of the subject is the same in each case, and the same aperture is used in each case, then the depth of field will be the same. What will vary is the perspective of the image, and how much of the background behind the subject can be seen. What a longer focal-length lens will give is a greater working distance between the subject and the front of the lens, minimizing the risk of disturbance to a small insect, for example, or giving sufficient space to illuminate the subject with flash.

Circles of Confusion

A "perfect" lens would transmit a point of light reflected from a subject, and focus it as a same-size point on the imaging surface. If the subject is flat, and parallel to the imaging surface, then all points reflected from the subject would be focused as points on the sensor. However, most of the subjects we photograph are not flat, and are at various angles relative to the imaging sensor. Light reflected from those parts of the subject lying on either side of the main plane of focus will be rendered as disks of varying size, called circles of confusion (CofC) or blur circles.

Because human vision is not perfect, it will accept certain circle sizes as sharp, even though they are not points. The size of the circle that is considered sharp will depend on various factors such as viewing distance of the image and degree of enlargement. There is a general consensus that a circle of $\frac{1}{30}$ mm (0.03 mm) will appear sharp. This is valid for 35 mm or full-frame imaging sensors, and takes into account an assumed size of final reproduction (usually 8 × 10 inches). A smaller sensor such as an APS-C size will need to be enlarged by a greater degree, and therefore the circle of confusion used to calculate DOF is smaller.

The figure of 0.03 mm is divided by the crop factor of the sensor to give a circle of confusion for a particular sensor size. For example, a sensor with a crop factor of 1.5× will use a CofC of 0.03 divided by 1.5 (i.e., 0.2 mm).

Diffraction

From the discussion so far it would seem reasonable that, in order to maximize depth of field, you should stop down the lens as far as possible, and if necessary, add more light to the subject, or give a longer shutter speed to allow a small aperture to be used. There is a major problem with this argument, though—the lens resolution is limited by an optical concept known as diffraction.

Most lenses suffer from various chromatic and spherical aberrations when used at full aperture. These aberrations are gradually reduced as the lens is stopped down. However, the effects of diffraction increase as the lens is stopped down, and there will come a point where the image quality begins to fall.

Most lenses give their optimum performance at two to three stops from their maximum aperture, perhaps f/8. Stopping down the lens to this region improves definition by eliminating off-axis rays of light and reducing lens aberrations such as chromatic and spherical aberration. Beyond this, resolution may be affected by diffraction, which limits the resolution of a lens. Diffraction does not suddenly cut in—it appears gradually as the lens is stopped down, and different lenses will have their own optimum apertures.

The physics of diffraction are complex, but simply, when light rays touch the edge of any opaque material, such as the blades of the iris diaphragm in a lens, they are bent due to the wave nature of light, and the light splits into separate colors (as in a rainbow). Violet rays are diffracted more than red. This is similar to water being passed through a hosepipe. If the nozzle is closed too much for the amount of water flowing through it, the water "spills out" around the edge.

Thus, there is a compromise between depth of field and resolution. For any given situation there is an optimum aperture, where the balance between

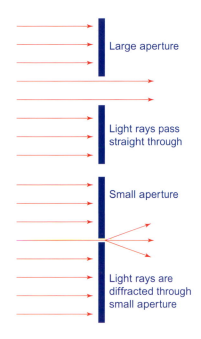

Large aperture

Light rays pass
straight through

Small aperture

Light rays are
diffracted through
small aperture

FIGURE 3.21 Light rays are diffracted when they pass through a small aperture.

sharpness and depth of field is optimized. It is worth doing tests with your lenses to see where the diffraction limit is, and how greatly the image is degraded at various apertures. It may be that, in certain instances, resolution needs to be sacrificed at the expense of greater depth of field.

A practical rule of thumb for minimizing the effect of diffraction is to keep the effective aperture (E_A) you are using below the diffraction limit. This will vary according to the size of the image sensor in the camera. Suggested figures are:

Full-frame sensor (24 × 36 mm): 32
APS-C-size sensor (e.g., 24 × 16 mm): 16

The effective aperture of the system is derived from a simple formula:

$$\text{Effective Aperture} = \text{f no.} \times (M + 1)$$

where M is the magnification at the sensor. The f no. is, strictly, the relative aperture of the lens, and is the number engraved on the aperture scale. For example, if the aperture ring on the lens is set to f/16, and the subject is being photographed at a magnification of 1×, then the effective aperture is

$$16 \times (M + 1) \quad \text{or} \quad 16 \times 2 = 32$$

Using a camera with an APS-C-size sensor, and this aperture/magnification combination, it is highly likely that image resolution will be reduced due

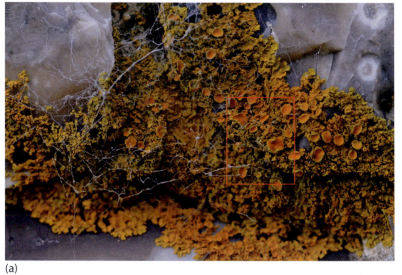

(a)

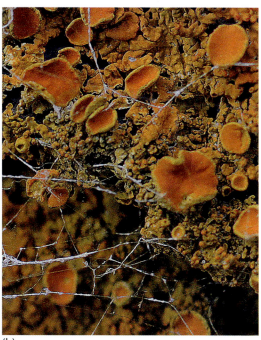

(b)

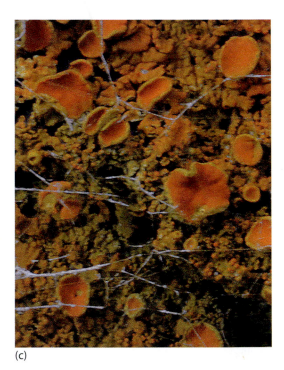

(c)

FIGURE 3.22 I found this lichen growing on the flint wall of a local church: (a) the original image was taken at a magnification of around $\frac{1}{2}\times$; (b) the second image was taken at f/5.6, and (c) the last at f/36. Although (c) gives greater depth of field, the whole image is soft, and lacks the crisp detail of (b) due to the effects of diffraction. Camera: Nikon D300, Micro-Nikkor 105 mm.

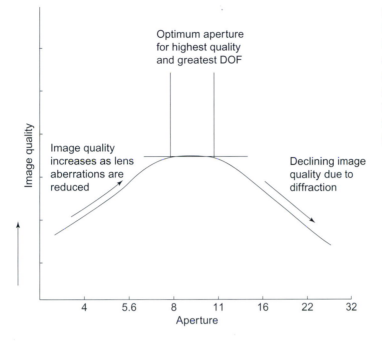

Optimum aperture
for highest quality
and greatest DOF

Image quality
increases as lens
aberrations are
reduced

Declining image
quality due to
diffraction

Image quality

4 5.6 8 11 16 22 32

Aperture

FIGURE 3.23 Stopping down the lens from its maximum aperture initially improves performance as lens aberrations are reduced. Beyond a certain point, however, the effects of diffraction start to degrade the image. The optimum aperture for performance for most lenses is two to three stops from its maximum.

to the effects of diffraction. To achieve a sharper result, it may be better to open the lens aperture by two stops, even though this will mean losing some valuable depth of field.

Although these figures are approximations, and image quality will be dependent on other factors, they do serve to show that different sensor sizes will affect final image quality. It is one of the reasons why apertures on compact cameras only go to f/8 or f/11. If the lens was stopped down any more, the image quality would suffer from diffraction. The type of subject will also have an effect on the final image quality; for example, a subject with lots of high-contrast detail may suffer more than one with smooth tones and little detail.

Several companies make depth-of-field calculators for field use, while others are available online where it is possible to select the sensor size, lens focal length, and focusing distance. They then give you an overall depth of field. Some of these are not designed for macro photography at magnifications over life size. There is also a diffraction calculator with images showing the effects of diffraction. Details of these can be found in the Resources chapter.

TABLE 3.1 Depth of Field for 35 mm–Size Sensor Using Circle of Confusion of 0.03 mm

Magnification	f/2.8	f/4	f/5.6	f/8	f/11	f/16	f/22	f/32
0.2	3.36	4.8	6.5	9.6	13	19	27	38.4
0.5	0.67	0.95	1.3	1.9	2.6	3.8	5.3	7.68
0.75	0.39	0.5	0.8	1.0	1.4	2.0	2.7	4.44
1	0.22	0.32	0.44	0.64	0.88	1.3	1.8	2.56
2	0.084	0.12	0.16	0.24	0.33	0.48	0.66	0.96
3	0.05	0.07	0.10	0.14	0.2	0.29	0.39	0.57
4	0.035	0.05	0.07	0.10	0.14	0.20	0.28	0.40
5	0.027	0.038	0.054	0.077	0.106	0.15	0.21	0.31

Note: Figures are in millimeters. Figures in red indicate where the diffraction limit has been exceeded and where image quality may be degraded.

TABLE 3.2 Depth of Field for APS-C-Size Sensor Using Circle of Confusion of 0.020 mm

Magnification	f/2.8	f/4	f/5.6	f/8	f/11	f/16	f/22	f/32
0.2	5.04	7.2	9.75	14.4	19.5	28.5	40.5	57.6
0.5	1.00	1.42	1.95	2.85	3.9	5.7	7.95	11.52
0.75	0.58	0.75	1.2	1.5	2.1	3.0	4.05	6.66
1	0.33	0.48	0.66	0.96	1.32	1.95	2.7	3.84
2	0.126	0.18	0.24	0.36	0.49	0.72	0.99	1.44
3	0.075	0.10	0.15	0.21	0.3	0.43	0.58	0.85
4	0.0525	0.075	0.10	0.15	0.21	0.30	0.42	0.60
5	0.040	0.057	0.08	0.11	0.16	0.22	0.31	0.46

Note: Figures are in millimeters. Crop factor is 1.5×. Figures in red indicate where the diffraction limit has been exceeded and where image quality may be degraded.

Bokeh

The word *Boke*, or *Bokeh*, is a Japanese word meaning to "become blurred or fuzzy." It is used to refer to the appearance of out-of-focus areas in an image, whether the transitions are smooth and uniform or coarse. Different lenses will have different characteristics with regard to their *bokeh*, often determined by the number of blades used in the lens diaphragm: The more blades used, the more circular the aperture and the smoother the result. Most modern lenses, particularly macro lenses, use diaphragms with eight or nine blades,

which make the aperture very close to circular, generally leading to excellent *bokeh*. At least one lens currently on the market, the Nikon 105 mm f/2 DC-Nikkor, features a defocus control to enable adjustment of foreground and background blurring without affecting the main point of focus. Although designed primarily for portraiture, it may well be worth trying for close-up and macro work, if used with appropriate extension tubes.

FIGURE 3.24 A good lens will give lovely subtle gradations between tones, such as the background behind this emerging Allium flower, and the Mayfly. Camera: Nikon D300 camera, Nikon 105 mm Micro-Nikkor; Allium: $\frac{1}{160}$ sec. at f/5.6; Mayfly: $\frac{1}{40}$ sec. at f/9.

Blurring a Background

There will be occasions when a small aperture will be required to achieve the required depth of field for a subject, but which, in turn, creates a distracting background by bringing elements in the background into focus. Also, subjects will not always be in the best position and therefore the background will not be inappropriate—for example, a flower growing up against a fence.

69

In these cases, it is possible to use image-processing software such as Adobe Photoshop to select the subject, and then apply a blur filter to the unselected background. The Gaussian blur filter in particular can be adjusted so that the amount of blurring can be tailored specifically to the image. Successful selection of the subject will depend on its characteristics: Does it have hard edges or fine hairs, for example? Further discussion of the techniques is beyond the scope of this book, but good information can be found in many of the books listed in the Resources chapter.

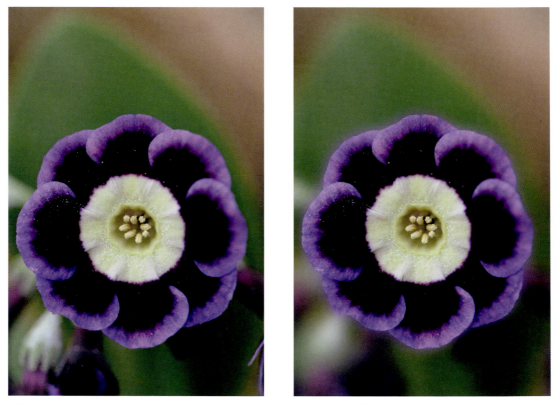

FIGURE 3.25 I shot this Auricula at a flower show, where I had little scope for controlling the depth of field. The background is rather distracting. I selected the flower using the Quick Selection tool in Adobe Photoshop CS4, inverted the selection, and applied a Gaussian blur (Filter > Blur > Gaussian Blur) with a radius of 75 pixels.

Summary

- Depth of field is limited in close-up and macro photography, and becomes less with increasing magnification.
- Depth of field is greater with smaller sensors.

- Diffraction affects image resolution at small apertures.
- Working distance increases with an increase in focal length.
- Depth of field remains the same for any focal length provided the magnification remains the same.
- Depth of field is doubled when you stop down the lens by two stops.

Stacking Images to Increase Depth of Field

The concept of combining several portions of images together to make one is not new, and has been used since the earliest days of photography when several negatives were printed onto the same sheet of paper.

Similar techniques can be used with good effect in close-up and macro photography. The most basic version of the technique is to shoot two or more images at slightly different focus points, and combine the sharpest sections of each using copying, pasting, and layering techniques in Adobe Photoshop.

In the example shown, two shots were taken in quick succession of this Banded Agrion damselfly, one focusing on the main body of the insect, the other refocusing on the plane of the wing. The camera was well supported on a tripod, and the insect, unusually, did not move between exposures. In Adobe Photoshop CS4 I used the Lasso tool to draw around the sharp wing area, including some of the background. A 5-pixel-radius feather was used to soften the edge of the selection. The selection was copied and then pasted into the first image with the sharp body. This automatically creates a layer that can be nudged into place using the Move tool. I usually reduce the opacity of the top layer to about 50 percent so that I can see the underlying image through it. Having aligned it perfectly, I returned the layer to 100 percent opacity to see the final result.

The technique has obvious limitations for moving subjects.

Tip
A selection can be nudged, one pixel at a time, using the arrow keys of the keyboard for precise alignment.

Stacking Software

A relatively new, more sophisticated technique for increasing depth of field within an image is to take a series of images at different focus points, and stack or blend them together automatically in an image-processing program. Several specific programs are available such as Combine ZM and Helicon Focus, while the latest version of Adobe Photoshop, CS4, has an "autoblend" facility for doing this.

The basic idea is to shoot a series of images of a subject at different focus points within the subject (the precise number will depend on the size of the subject). This can be done either by moving the entire camera for each exposure, or refocusing the lens. By using a fairly wide aperture, for example f/5.6, diffraction will not be an issue, and you will be using the optimum

aperture of the lens, as well as keeping the background out of focus. The images are then loaded into the software package, which then analyzes the images and selects the sharpest sections of each one and blends them together. In most cases this works remarkably well, though occasionally some retouching may be required of artifacts that have been formed during the process.

Moving the camera or refocusing the lens for each image leads to some perspective distortion of the subject. If you have a focusing rail, use this to move the camera toward the subject by equal amounts, though it is not strictly necessary.

FIGURE 3.26 I shot two images of this damselfly, one focusing on the body, the second focusing on the wing, which is perhaps a millimeter or so in front of the plane of the body (the camera was on a sturdy tripod). (a) Using the Lasso tool with a 5-pixel feather, I made a rough outline around the sharp wing, copied it, and then pasted it into the image with the sharp body. The pasted image automatically becomes layered. (b) I reduced the opacity of this layer to 50 percent so that I could see through it to the wing underneath, and then moved it so that it exactly aligned. (d) I then put the opacity back to 100 percent and flattened the image.

(a)

FIGURE 3.26 *Continued*

(b)

(c)

FIGURE 3.26 *Continued*

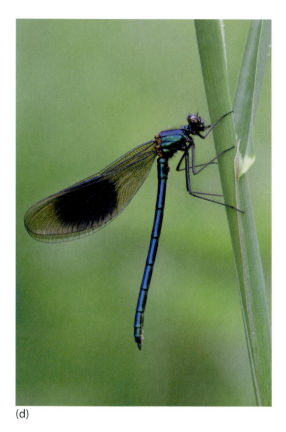

(d)

FIGURE 3.27 A more sophisticated form of image stacking is to shoot a series of images at different focus points through a subject. For this image of a Strelitzia flower I shot six images, which were loaded into Adobe Photoshop layers (Bridge: Tools > Photoshop > Load Files into Photoshop Layers).

(a)

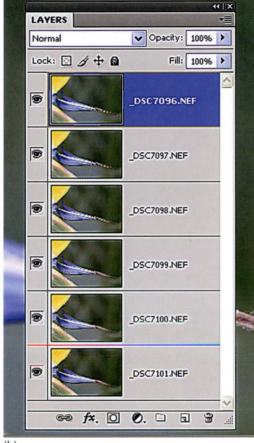

FIGURE 3.27 *Continued*

(b)

FIGURE 3.28 (a) The first step is to use Auto-Align (Edit > Auto-Align Layers), followed by (b) Auto-Blend (Edit > Auto-Blend Layers). Note this dialog box also has the facility to stitch together multi-image panoramas. (c) The final stacked image is sharp from front to back of the flower but the background remains virtually the same. Camera: Nikon D300, 105 mm Micro-Nikkor, $\frac{1}{50}$ sec. at f/5.6.

(a)

(b)

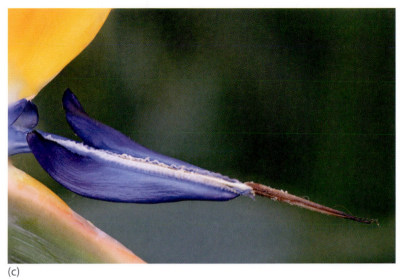

FIGURE 3.28 *Continued*

(c)

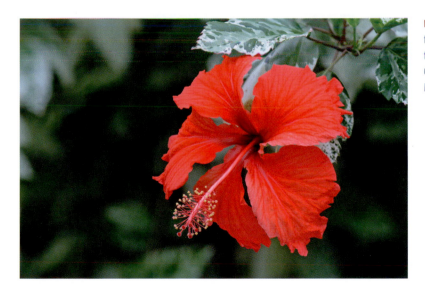

FIGURE 3.29 Hibiscus flower "stacked" from six images, producing sharp focus from front to back of the flower. Camera: Nikon D300, 105 mm Micro-Nikkor, $\frac{1}{60}$ sec. at f/5.6.

FIGURE 3.30 Tip of hypodermic needle stacked from four images shot at 5×. The image was lit with the light from two fiber optic light guides. The camera was mounted on a sturdy focusing rail, allowing very precise focusing through the minute subject. Camera: Canon 1000D, Canon MP-E65 mm macro lens, $\frac{1}{60}$ sec. at f/4.

Camera Supports

Holding the camera still at the point of exposure is critical in all areas of imaging, but especially with close-up or macro photography, where the slightest movement may be magnified and exhibited as camera shake. There are several forms of camera supports applicable to macro imaging, but the crucial characteristic of them all must be to hold the camera still at the moment of exposure, and enable precise movement of the camera when composing and focusing the image.

Tripods

For studio work it may be useful if a tripod has a central column that can be raised or lowered easily. For work in the field, particularly with subjects such as low-growing plants, a tripod that can hold the camera at ground level may be useful—the Benbo is a well-known brand, and very versatile in this respect. All three legs of the tripod can be moved independently, and the center column tilted to any angle, allowing the tripod to be placed in virtually any position from ground level upwards. Take great care to get the center of gravity right if you are using a Benbo tripod, so that it doesn't fall over, and also to hold on

FIGURE 4.1 A sturdy camera support is virtually essential to get sharp images of small subjects such as these mating flies. I was fortunate that they were perched on a leaf on the edge of a patch of vegetation, so I could slowly move a tripod into place, and align the camera as far as possible so that it was parallel with the main plane through them. Camera: Nikon D300, 105 mm Micro-Nikkor, $\frac{1}{60}$ sec. at f/5.6, Benbo tripod.

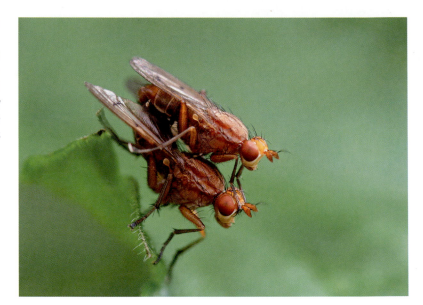

to the top of the tripod when the central handle is released, as this loosens all the legs and the column, and it can easily collapse. Other models that have great versatility for close-up and macro work are the Gitzo Explorer and Manfrotto X ranges. Although expensive, carbon fiber models are much lighter and equally, if not more, stable than their aluminum cousins.

FIGURE 4.2 The British-made Benbo tripod is incredibly versatile at holding a camera in a variety of positions. Also shown is the Wimberley Plamp, which has a flexible arm for holding reflectors (in this case a folding Lastolite) or supporting plants. Note also the right-angle finder attached to the camera viewfinder.

Monopod

Monopods are used primarily by close-up photographers for photographing insects in the field, where the use of a tripod might disturb the subject too much. A monopod can be "planted" in the ground, and rocked backwards and forwards in relation to the subject to achieve focus. Although not as stable as a tripod, monopods are certainly worth considering if you are intending to photograph insects in the field.

Tripod Heads

There are two main types of tripod head: the ball and socket, and pan and tilt. My own preference for close-up and macro photography is for the ball and socket, as it doesn't have any protruding arms that may get in the way, particularly when being carried in the field. It is worth investing in a large, solid ball-and-socket head, such as the Arca Swiss Monoball, to support the camera rigidly.

A pan-and-tilt head enables precise positioning in one plane at a time and is perhaps better suited to studio work. Quick-release plates that screw onto the camera and are slotted into the tripod head are a very convenient and quick way of mounting the camera onto a head. There are several systems in current use, but the two main ones are the Arca Swiss, using a rectangular plate, and the Manfrotto, which uses both hexagonal and rectangular plates.

One useful accessory is an L bracket, which fits underneath the camera and allows you to rotate it from a horizontal to a vertical position around the lens axis, without changing the shooting position in any way. They are manufactured for specific cameras by companies such as Kirk Enterprises, and slot into the Arca Swiss–style quick-release system.

Focusing Rail

When shooting close-ups it is often easier to focus by moving the whole camera backwards and forwards rather than rotating the focus ring on the lens. To help do this, focusing rails are available on to which the camera is mounted. These can then be used to make precise adjustments in the camera-to-subject distance. Several models on the market, such as the Novoflex Castel-Cross, allow adjustment in two directions.

Bean Bag

This rather low-tech device may prove to be invaluable in some situations. Bean bags are usually made from cloth or other fabric and filled with dried

FIGURE 4.3 A wide variety of focusing rails are available. This Novoflex model has the ability to move the camera in two planes.

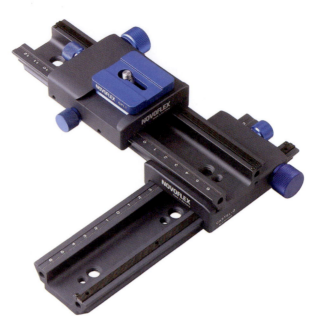

FIGURE 4.4 A sturdy tripod and precise focusing rail were needed for this six-shot image "stack" of a stinging nettle stem, showing the stinging hairs. Camera: Canon 1000D, MP-E65 mm macro lens, each image at f/4.

beans or polystyrene beads. The bag is laid onto a surface, perhaps the ground in the case of a plant, and the camera and lens pushed into the surface. They provide a remarkably firm support, though are obviously very limited in where they can be used. Wildlife photographers use them extensively when shooting with long lenses from vehicles on safaris, when they are draped over the window ledge. When traveling on planes, they can be carried empty to save weight, and filled at your destination.

Remote Release

With any form of camera support, even the sturdiest tripod, it is possible to introduce movement into the system by heavy-handed firing of the shutter. This can be eliminated by the use of a cable release or other form of remote shutter release. All digital cameras will have a socket for an electronic remote release. Despite being quite expensive, remote releases are a virtual necessity for getting the sharpest results. There is a range of models available, from simple on–off switches, to devices enabling time-lapse intervals to be programmed. Infrared and wireless radio remotes are also available for firing the camera at a distance.

FIGURE 4.5 This shot of Honey Fungus growing in autumn needed a 5-second exposure to allow me to use an aperture of f/22. A sturdy camera support, remote release, and mirror lock-up facility were all used to ensure a sharp image. Camera: Nikon D200, 18–200 mm lens set to 150 mm, 5 sec. at f/22.

FIGURE 4.6 I found this Broad-Bodied Chaser dragonfly resting on a cold, dull morning. I needed to align the camera so that the sensor was parallel to the main body of the insect. I swung the central column of the Benbo tripod over the top and focused on the body. As the leaf was swaying in the breeze, I could only use an exposure of $\frac{1}{20}$ second at f/8, meaning that the whole insect is not totally sharp (see the wing tips and legs). Camera: Nikon D200, 105 mm Micro-Nikkor, $\frac{1}{20}$ sec. at f/8.

In situations where you do not have a remote release it is possible to activate the shutter via the delayed-action control on the camera.

Even with a cable release there may be residual vibration caused by the mirror flipping up before the exposure is made. Several cameras have a mirror lock-up facility, whereby pressing the cable release once locks the mirror out of the light path. Wait a few seconds for the vibration to die down before pressing it a second time to open the shutter. This is only useful if the subject is static, and not likely to move in between the mirror being raised and the shutter opening.

Lighting

The success of any photographic image is determined largely by the lighting—its quality, quantity, and color. There is no such thing as perfect or standard lighting for close-up and macro photography. Each subject will require something different, and different photographers will photograph the same subject using different lighting techniques to create different images. There also will be instances where a standardized lighting setup is required—for example, for a series of comparative images of coins. It is highly likely that, in many cases, you will need to use a combination of lighting techniques, such as daylight with flash fill in, for example.

The basic choice is between natural light (daylight) and artificial lighting (usually, but not always, electronic flash). Other small light sources that might be useful are small reading lamps, available from most furnishing and office supply stores, and focusable microscope lamps. One of the characteristics of daylight is that it is unpredictable and variable, which is fine for a one-shot photograph of a subject, but is not appropriate if a series of images is required with consistent lighting.

FIGURE 5.1 Nothing can really beat natural daylight for the photography of natural subjects, as shown in these images of (a) a Banded Agrion damselfly (Banded Agrion), and (b) the seed pod of Bristly Fruited Silkweed found in Sardinia. The seedpod was held in place with a Wimberley Plamp. Camera: Nikon D300, 105 mm Micro-Nikkor.

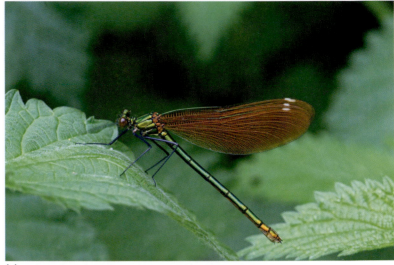

(a)

(b)

In general, when using artificial light, small subjects require small light sources. The quality of light from a light source will be partly determined by the relative size of the light source and subject. If the light is a reasonable distance away, such that it is effectively smaller than the subject, then it will act like a spotlight, creating shadows that will accentuate texture, but that may need to be softened. When used closer to a subject, the light becomes softer as the size of the light source becomes larger than the specimen.

(a)

(b)

FIGURE 5.2 (a) When the light source is effectively smaller than the subject it acts like a spotlight, creating harsh shadows and accentuating texture. (b) When the light source is effectively larger than the subject it produces much softer light with softer shadows.

For very small specimens, where texture and depth are important, small focusable lamps will be useful. These are available from microscope suppliers and are usually tungsten based, and give off a reasonable amount of heat.

When using any form of artificial lighting, start by using one light to provide modeling and relief, as appropriate to the subject. Place it above and to one side of the subject, usually to the left by convention. Try filling in shadows with white card or silver foil reflectors. If a second light source is required, it is imperative that you do not create a second shadow. A lighting ratio of 3:1 between the main light and fill-in light will generally give good results,

though this will depend greatly on the subject and your personal preference.

Daylight

Daylight varies in quantity, quality, and color, depending on weather conditions, time of day, or time of year. It is the preferred source for natural subjects such as flowers and insects, but because of its unpredictable nature, it may not always be appropriate. Some subjects, such as delicate flowers, may require soft, even lighting to show detail in all areas of the image, while others, such as lichens, may require a harsher, more directional light to accentuate texture. Backlighting will give a totally different effect with some subjects.

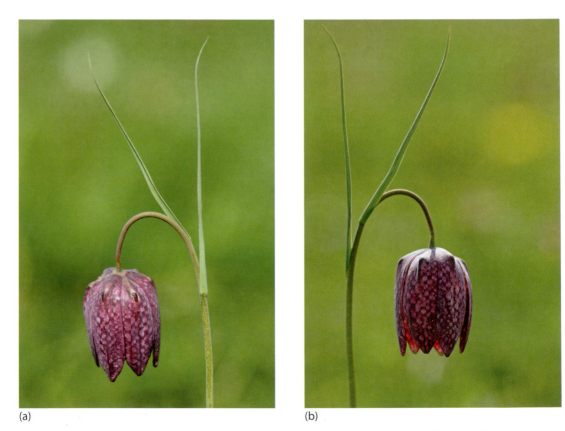

(a) (b)

FIGURE 5.3 The same Fritillary flower photographed using (a) frontal lighting and (b) backlighting. There is more detail in the frontal light shot, but the backlit version shows the translucent petals. Neither is right or wrong! Camera: Nikon D300, 70–200 mm lens set to 150 mm.

White Balance

The color of daylight varies throughout the day, and although the auto–white balance (AWB) facility in modern digital cameras is remarkably good, it may be worth using a light-balancing tool to ensure perfect color capture, particularly if you are shooting in mixed-lighting conditions, perhaps in a greenhouse lit with artificial lamps, for example.

Traditionally, photographic gray cards—sheets of card manufactured with a perfectly neutral gray surface that reflect 18 percent of the light falling on them—were used by photographers to help when producing color prints. Today, white balancing devices are available as plastic sheets or circular folding units. They can either be used to white balance the camera at the time of exposure, or included in the scene being photographed to enable correction in image-processing software. Make sure that the card receives the same light as the subject. You might shoot two images of the same scene, one with and one without the card. Imaging software such as Adobe Photoshop has a white balance facility. Click the white balance dropper on the image of the gray card and that area is immediately balanced to a neutral gray. This is an area where shooting RAW files has great advantages over JPEG files.

Gray card and other white balance tools are available from the companies listed in the Resources chapter.

(a)

FIGURE 5.4 The delicate color of flowers can be difficult to record accurately, particularly blue and purple flowers. (a) I handheld an 18 percent gray card in front of this Spanish Bluebell flower and shot an image of it, making sure it received the same light as the flower. (b) In the RAW converter software (Adobe Camera Raw) the histogram has a blue cast at the right end. I used the white balance dropper to click on the gray tool to neutralize the color. (c) I then selected both images and synchronized them so that the flower image received the same adjustment as the gray card, ensuring the correct color balance. Camera: Nikon D300, 105 mm Micro-Nikkor. $\frac{1}{50}$ sec. at f/5.6.

FIGURE 5.4 *Continued*

(b)

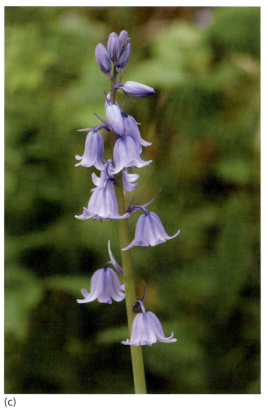

(c)

Continuous Light Sources

Continuous light sources include tungsten and quartz halogen bulbs. Their main advantage is that they allow you to predict exactly how the final image will appear. They generate a lot of heat though, making them unsuitable for delicate living subjects. They may require long shutter speeds, making them also inappropriate for moving subjects.

Subject Brightness Range

In general, digital cameras cannot record all the tones that the human eye can see. A typical bright sunny day might have a brightness range of well over eight stops, and the highlight may be several thousand times brighter than the shadow. A typical digital camera is only able to record successfully a range of around five stops, meaning that detail might be lost in either the shadows, highlights, or both. Several ways to modify the light are available, from diffusers and reflectors, to the use of electronic flash to "fill in" the shadows. Each device will have its own characteristics, and it is worth trying more than one to see which suits your particular subject.

Reflectors

The main aim of a reflector is to reflect light into the shadow areas of a scene, brightening them, and thus reducing the overall contrast. Many reflective surfaces can be used to reflect light back into shadows, from white card and paper to silver foil and mirrors. Each will have its own characteristics depending on the surface and size. Several manufacturers market a range of circular reflectors, many of which fold up into small pouches for carrying. Lastolite has an extensive range, including white, silver, and gold. For most close-up and macro photography you will only need the smallest one, 30 cm in diameter, which folds down to a pocket-size 10 cm. The version with one white side and one silver side is probably the most useful. Small pieces of white card or silver or mirrored card are also well worth keeping in your camera bag. One good source is the silvered lids of Chinese food take-away containers.

Diffusers

A diffuser is held between the light source and subject to soften the light, much like a cloud passing across the sun. Like reflectors, several diffusers are available commercially, either as circular fold-up types or umbrellas, but they also can be improvised from tracing paper or greenhouse muslin, for example. If you are using an alternative material to a commercial diffuser, such as tracing paper, it might be worth checking that the material being used

FIGURE 5.5 The lighting on this small alpine plant is too harsh, giving deep shadows. A white reflector was placed to the right, reflecting light back into the shadows, giving a much more pleasant effect.

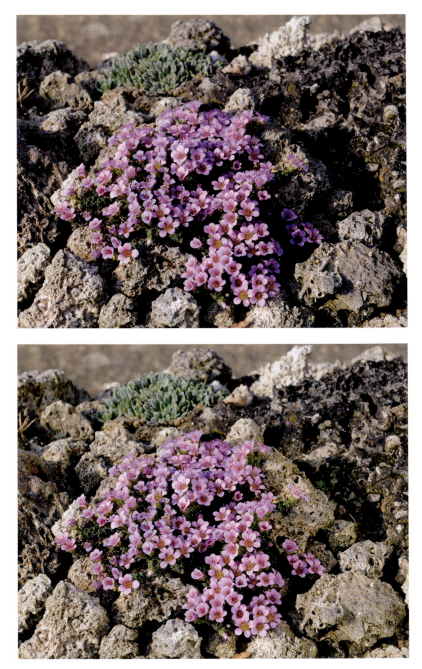

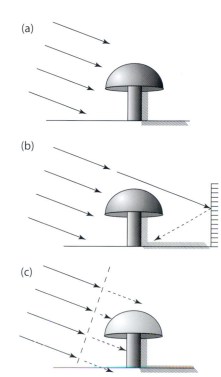

(a)

(b)

(c)

FIGURE 5.6 (a) Harsh sunlight creates deep shadows and a subject brightness range greater than the camera can record. The result is black shadows with no detail. (b) A reflector can be used to reflect light back into the shadows, reducing the overall contrast. Silver will have a greater effect than white. It will have no effect if there is highlight on the top right of the specimen. (c) A diffuser placed between the subject and sun acts like a cloud softening the light. It will tone down a bright highlight.

is neutral in color, and not adding a color cast to the image. You can do this simply by photographing an 18 percent gray card or equivalent with the light shining through the diffuser (see White Balance box).

Flash

Electronic flash offers the advantage of a small, powerful, consistent light source, that when used with modern digital cameras, can be used as the main light source or in conjunction with ambient daylight to provide fill in, just like a reflector. Although it is generally thought that flash will "freeze" the movement of subjects, it is worth remembering that many flash units have a flash duration of only around $\frac{1}{500}$ second, and blurring may still occur with fast-moving subjects. Photographers, such as Stephen Dalton, who photograph insects in flight, use specialized high-speed flash units with durations up to $\frac{1}{25,000}$ second or less. If you intend to do any of this type of work, it is worth checking the technical specification of your flash guns. Working indoors, flash can be used to provide all the lighting for a subject, but outdoors, flash can be used in a variety of ways in combination with daylight. However you use flash, the general aim should be that it shouldn't be apparent, and the result should look as natural as possible.

FIGURE 5.7 (a) This fossil fish is embedded in a flat slab of limestone. (b) To emphasize surface texture I positioned a small flash gun at an acute angle to graze the surface of the specimen. Note the scale alongside the fossil. Camera: Nikon D300, 105 mm Micro-Nikkor, $\frac{1}{60}$ sec. at f/11.

(a)

(b)

FIGURE 5.8 The fossil was enclosed in a light tent (a white plastic lamp shade), giving a much softer effect, with little information with regard to surface relief. Camera: Nikon D300, 105 mm Micro-Nikkor, $\frac{1}{60}$ sec. at f/11.

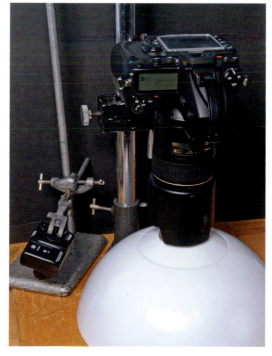

FIGURE 5.9 A similar pair of a coin, (a) with grazed light and (b) with diffuse light through the light tent. Camera: Nikon D300, 105 mm Micro-Nikkor, $\frac{1}{60}$ at f/5.6.

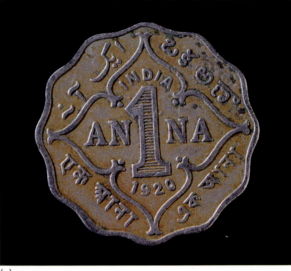

(a)

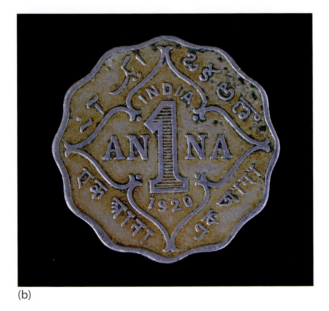

(b)

(a)

FIGURE 5.10 (a) Sea Urchin test lit with one light from the left side, giving high contrast and a lack of detail in the shadows. (b) Adding a silver reflector fills in the shadows on the right side, but the rear of the shell starts to merge with the background. (c) A second flash from behind the shell lifts it from the background.

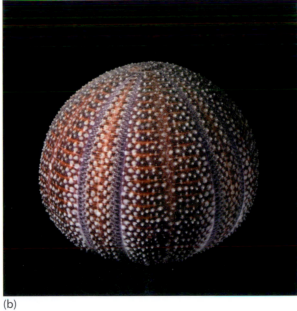

(b)

FIGURE 5.10 *Continued*

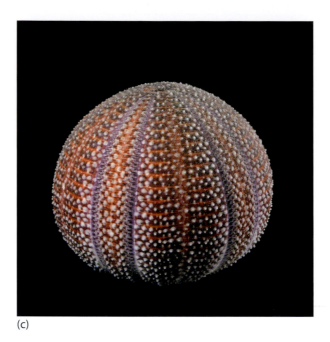

(c)

Flash with Daylight

Small electronic flash units can be used in combination with daylight to balance light ratios. By varying the flash output, its power relative to daylight can be altered, and a wide range of lighting effects achieved. The two main ways it is used are:

- Daylight as the main light and flash as fill in.
- Flash as the main light and daylight as fill in.

Daylight as the Main Light and Flash as Fill In

Imagine you are photographing a toadstool in reasonably harsh sunlight (perhaps a subject brightness range (SBR) of 400:1). The camera's TTL meter gives an exposure of $\frac{1}{60}$ second at f/11. If you now add a flash to this setup, and set it to give a correct exposure at f/11, the subject will be overexposed because it has received two lots of "correct" exposure. However, if you dial in −1 EV compensation on the flash, it will make the daylight dominant and the flash will act as a fill in. Try experimenting with different compensation settings. For a midtoned subject, a −1.7 EV setting might give a more pleasing result, whereas with a very pale subject, a setting of −0.7 EV might be better.

Flash as the Main Light and Daylight as Fill In

Imagine the same toadstool growing in a dense woodland, with heavy overcast lighting. In this case, flash can be used to provide the main light,

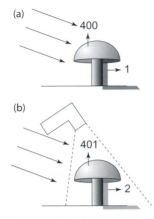

FIGURE 5.11 (a) If the SBR is 400 : 1 (where the highlight is reflecting 400 units of light and the shadow is reflecting 1 unit) and the weak flash is adding just 1 unit of light to the overall scene, (b) the SBR becomes 401 : 2 or 200.5 : 1, thus reducing the contrast by one-half. Notice that the shadow is affected proportionately far more than the highlight. This is one of the reasons why wedding photographers often use fill flash on bright sunny days—the contrast between the white dress of the bride and the black suit of the groom is far too much for the camera. Similar techniques are used by bird and animal photographers, for example, for brightening dark plumage or adding a catch light to an eye.

and add a "sparkle" to the subject. You will need to use an extension cable to get the flash into the right position above and to one side of the subject, or perhaps from the side or back. Use the aperture that is correct for the flash (e.g., f/11). If the standard flash synchronization speed of $\frac{1}{125}$ second is used, the background will register as very dark or even black. Instead, use the corresponding shutter speed that matches the f/11 of the flash gun. In some instances this may be as low as $\frac{1}{2}$ or 1 second or more. When the shutter is triggered, the flash goes off and exposes the toadstool correctly. The shutter now stays open for the longer time, effectively filling in the shadows created by the flash, and allowing the background to register.

This technique does have one major drawback: If the subject is moving, perhaps in a breeze, although the flash will freeze it during the flash exposure, any movement during the daylight part of the exposure will register as a "ghost" image.

Almost all situations in the field will be different, and it is well worth experimenting with different flash settings for a range of subjects to achieve the effect you are after.

The discussion thus far deals with the principles of using flash with daylight. Modern, sophisticated flash units such as the Nikon SB800 take away much of the calculation and guesswork involved. The "slow-sync" facility, for example, available on many modern cameras, automatically balances ambient light

(a) (b)

FIGURE 5.12 Lobster Claw flowers *(Heliconia rostrata)* in a botanic garden glasshouse. (a) The daylight shot at $\frac{1}{40}$ at f/8 is rather dull and flat due to the diffuse ambient light. (b) This shot at $\frac{1}{60}$ at f/8 using the Nikon macro flash SB-R200 system with two heads is rather contrasty. (c) This shot at $\frac{1}{30}$ at f/8 allows more daylight to register, giving a more natural effect. Camera: Nikon D300 with 105 mm Micro-Nikkor lens.

with flash, giving long shutter speeds to prevent the background from becoming too dark.

Wireless flash units such as the Nikon Creative Lighting System offer the option of complete flexibility with regard to the positioning and relative power of flash units without worrying about trailing cables.

Ring Flash

A ring flash is a circular flash tube that is mounted onto the front of the lens, and provides flat, shadowless lighting across the subject. They were originally designed for medical work such as dental or surgical photography. Because of the featureless lighting, their use is limited to certain subjects, such as trumpet-shaped flowers where it can be difficult to light the interior of the

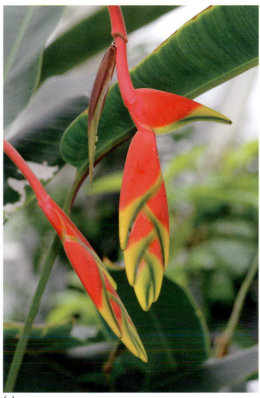

FIGURE 5.12 *Continued*

(c)

flower. Some units are available with two or more separate tubes that can be controlled independently, thus enabling the creation of shadows. When using a traditional ring flash try covering a portion of the tube (usually the bottom left or right quadrant) with black tape, which will create a shadow.

Specialist Macro Flash Units

Several manufacturers, including Canon and Nikon, make devices that hold one or more flash units on the front of the lens. One example is the Nikon RC1 Remote Speedlight System. It consists of a ring that screws into the front of the lens that can hold up to eight small flash heads, which can be placed in any position around the ring and angled in the appropriate direction. This system is particularly flexible when switching from landscape to portrait mode. The ring is rotated so that the flash units are in the same relative position as the landscape format. Separate flash heads can also be used to light the background or provide backlighting. The system is wireless, being controlled either by a "commander" unit or by the camera in "commander"

FIGURE 5.13 An old ring flash unit with the flash tube completely encircling the lens gives a very flat lighting effect.

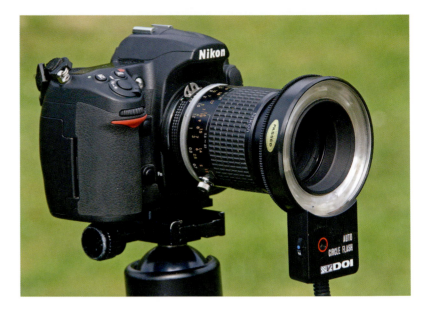

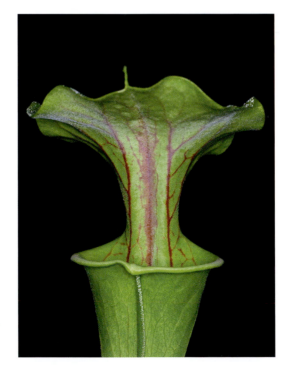

FIGURE 5.14 The lighting from the ring flash gives no clues as to depth or texture with this Sarracenia Pitcher. Camera: Nikon D300, 55 mm Micro-Nikkor, $\frac{1}{125}$ sec. at f/8.

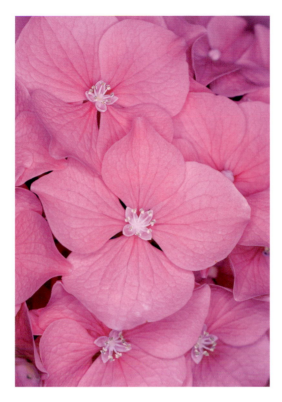

FIGURE 5.15 Hydrangea lit with a ring flash. The flat lighting here shows detail in all parts of the plant. Note the shadow all round the individual flowers. Camera: Nikon D300, 55 mm Micro-Nikkor, $\frac{1}{125}$ sec. at f/8.

mode. The power from each flash head can be controlled independently, enabling different lighting ratios. Each flash head has a modeling light that enables precise positioning of the flash, though this is probably not very useful in strong daylight.

Custom-Made Flash Brackets

There will be occasions when photographing small subjects in the field where any form of camera support is impractical, and you will need to handhold the camera. As discussed in Chapter 3, several macro lenses now have image-stabilizing facilities to help do this, but it is likely that you will need to use electronic flash, particularly for very small insects. Many photographers construct their own brackets to hold one or more flashes when photographing subjects such as insects in the field. What is required is a flexible arm that is capable of holding a flash gun in a range of positions relative to the lens: above, to the side, or halfway between the two. Such brackets can be relatively easily constructed from strips of metal, rigid or flexible ("gooseneck") arms, and small ball-and-socket heads. You will need an extension cable to trigger the flash when it is used externally to the camera.

FIGURE 5.16 The Nikon macro flash system with two SB-R200 flash heads mounted on a ring around the lens. The power of each flash unit can be adjusted to allow for a main light and fill-in light, for example. The pop-up flash on the camera is used to control the two flash heads via an infrared signal.

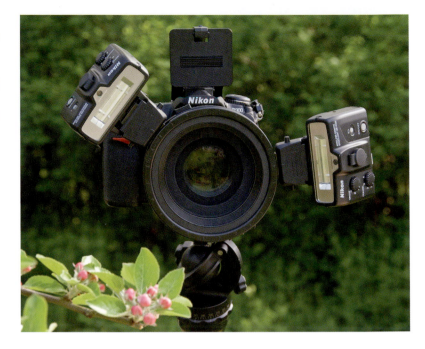

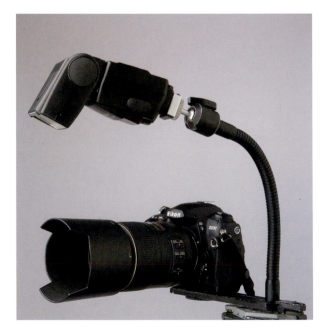

FIGURE 5.17 A simple flash bracket for field work. A flexible "gooseneck" arm with a small ball-and-socket head holds the flash gun in a variety of positions to give a range of lighting effects (the connecting cable has been removed for clarity). This particular setup becomes rather awkward when the camera is used in vertical format.

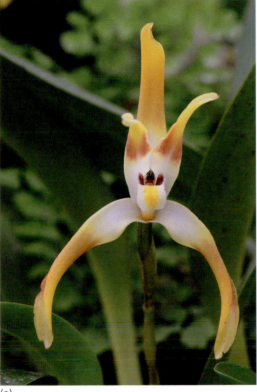
(a)

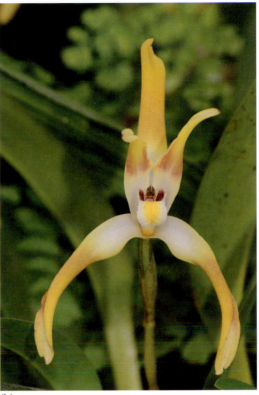
(b)

FIGURE 5.18 (a) Here I used the flash bracket to brighten up this orchid *(Maxillaria luteo-alba)*. (b) Note the warmer colors in this flash version. Camera: Nikon D300, 105 mm Micro-Nikkor, $\frac{1}{60}$ sec. at f/8, Nikon SB800 flash gun.

FIGURE 5.19 This Hornet was busy building a nest on the inside of the roof of my garden shed. I handheld the camera, and used the flash bracket with a single flash above and to the left of the lens. Camera: Nikon D300, 105 mm Micro-Nikkor, $\frac{1}{125}$ sec. at f/16.

105

If necessary, a second, less-powerful flash gun can be used to fill in the shadows caused by the primary flash. This can be mounted as close as possible to the camera—there is no point in filling in shadows that the camera lens can't see. Alternatively, a small reflector can be held on the other side of the flash to fill in the shadows.

A softer light can be obtained by firing the flash through a diffuser, either on the flash head, or with a diffuser mounted around the lens like a collar.

The whole point of this bracket is to provide a small portable unit for use in the field, so it must be easy to carry, lightweight, quick to set up, and easy to use. The design shown here is not very flexible for shooting portrait-format images

Several manufacturers make flash brackets, such as Kirk, Really Right Stuff, Wimberley, Novoflex, and Manfrotto.

Fiber Optic Light Source

Fiber optic light sources are available that offer highly controllable, small light sources. They generally consist of a quartz halogen light source inside a metal box, which is fed into one, two, or more flexible arms, usually around 1.5 feet long (0.5 meter), containing lengths of glass fiber that channel the light. One example is the Kaiser Macrospot 1500. Some units also have an electronic flash tube, making them excellent for freezing the movement of subjects such as pond life or small insects. Their great advantage is that the light source emitted from the fiber optic arms is cold, and so it can be placed close to living subjects. The arms can even be immersed in water if appropriate. Although expensive, fiber optic sources are excellent for small subjects, and secondhand units often can be found on Internet auction sites such as eBay.

Be careful when using fiber optic light sources to not bend the arms excessively, as this can fracture the glass fibers.

Light Box

A small light box can be very useful in the macro studio for photographing transparent or translucent subjects such as leaves, fern fronds, and the like. Ideally, it should be daylight balanced, though images can be easily color balanced in software, particularly if you are shooting RAW files. Once you have framed the subject in the camera on the light box, mask off the rest of the light box area with black paper or card to minimize flare.

Special Lighting Techniques

There are several special lighting techniques you can use.

Tent Lighting

Tent lighting is used for highly reflective subjects such as coins or other metallic subjects. The subject is effectively enveloped by a white translucent tent through which light is shone. Tent-style units are now sold for photographing small products for advertising items on Web sites such as eBay, but for many small subjects you will need smaller tents. White translucent plastic coffee cups with the bottoms removed, or white Perspex translucent lampshades are very useful (available in most furniture or lighting stores), though you can also construct one from tracing paper.

When working with the Canon MP65 lens, because the distance between lens and subject is so small, I often attach a collar around the front of the lens

 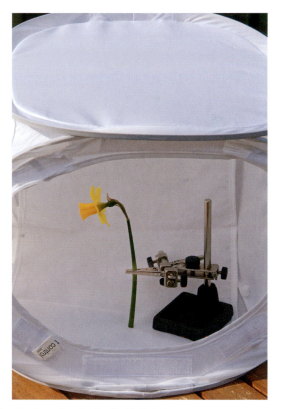

FIGURE 5.20 A small portable light tent being used on a table in a garden. Different backgrounds can be placed inside the tent.

FIGURE 5.21 A Daffodil flower shot inside the tent from Figure 5.20 with daylight showing the lovely soft light that this technique gives. Camera: Nikon D300, 105 mm Micro-Nikkor, $\frac{1}{50}$ sec. at f/22.

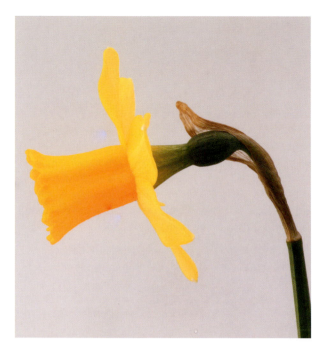

made from a white plastic coffee cup with the bottom removed. The lights are shone through the collar. Great care is needed to check for flare, particularly as there probably will be no room for a lens hood.

Do be careful that the tent lighting does not eliminate completely the natural gloss from a surface. Materials such as stainless steel, silver, or flint have a natural surface sheen that needs to be indicated in the image. If tent lighting is used for these subjects it may be possible to introduce this sheen by placing a piece of silver foil inside the tent.

Similarly, if the subject has a surface texture, this needs to be retained. Try shining light through just one side of the tent to give some modeling to the texture.

Dark-Field Lighting

This is a technique derived from microscopy for viewing transparent or translucent subjects. The subject appears to glow against a black background. Light is shone through the subject at an angle, such that if the subject were not present, no light would appear in the lens. Any light deflected by the subject is seen through the camera. You will probably need to use at least two lights for this technique. It is worth taping strips of black card to the sides of the flash units to direct the light more accurately and reduce the risk of flare.

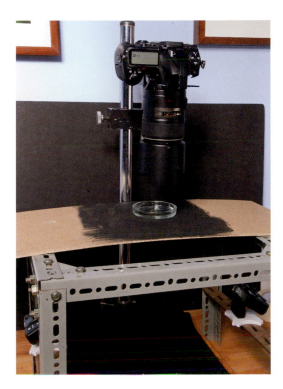

FIGURE 5.22 Dark-field lighting setup. Two Nikon SB-R200 flash guns are mounted underneath the Petri dish containing the specimen, and angled such that they shine light through the specimen, but not directly into the lens. Black velvet is placed under the subject.

(a)

FIGURE 5.23 (a) A Damselfly nymph from a garden pond photographed using the dark-field setup. Despite filtering the water, there will inevitably be lots of particles that can show up like a snowstorm. (b) Here I have retouched them in Adobe Photoshop. Camera: Nikon D300, 105 mm Micro-Nikkor, 1/60 sec. at f/11.

FIGURE 5.23 *Continued*

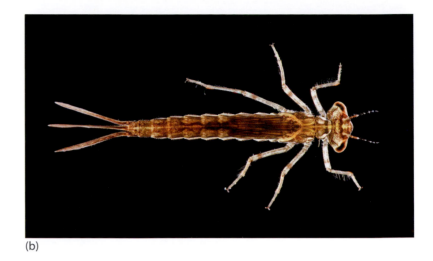

(b)

FIGURE 5.24 Two lights are directed through the subject at such an angle as to not shine into the camera lens. The only light that the camera will see is light deflected by the subject.

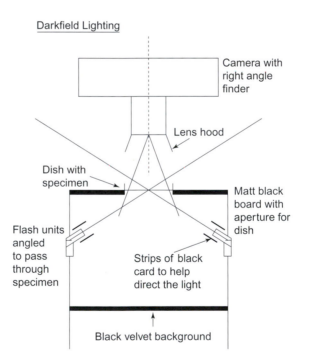

Short-Duration Events

Electronic flash is a short-duration light source with a maximum duration of around $\frac{1}{400}$ second, with some units capable of $\frac{1}{25,000}$ or less (the Nikon SB800 has a range of around $\frac{1}{1000}$ second to $\frac{1}{41,600}$ second depending on the setting

used). This means that short-duration events, such as insects in flight, can be photographed. The main challenge is to open the shutter and trigger the flash at the right time, usually achieved by the insect flying through the light beam. The topic is complex, involving the discussion of triggering systems and specialist shutters, and is beyond the scope of this book. Some references are given in the Resources chapter. However, some subjects are relatively easy, and a couple are included in Chapter 8.

The Macro Studio

I have used a wide variety of "studios" over the years for close-up and macro photography, from conservatories and glasshouses, to kitchen tables and windowsills, to fully equipped photographic studios.

To start with, don't underestimate the space you will need for macro photography. Even though your subjects are small, you will need enough space to separate the subject from a background and decide the distance from camera to subject, as well as space for lights, subject supports, and the like. You may need to place a light behind the subject to backlight it, for example. Very often, the main problem encountered with macro photography is the physical one of arranging camera, lens, lights, reflectors, subject support, and background without them all touching each other.

You may well need to improvise, or build your own equipment. I have a small rectangular "macro table," which I constructed from the Dexion slotted angle system (see Chapter 5), that I use primarily for dark-field lighting of small aquatic subjects. It can have lights attached to it in various positions. The bolts for constructing Dexion are $\frac{1}{4}$ in., the same as many camera fittings, which is convenient when attaching small ball heads and the like.

Because of the size of the subject, you will often need to improvise equipment for supporting subjects, holding reflectors, or moving the subject by very small amounts. You will inevitably find a small kit with soft brushes, forceps, scissors, scalpel, and tweezers very useful, together with a range of different adhesive tapes, Blu Tack, and small pieces of mirror. Glass petri dishes and small plastic containers are useful for holding small aquatic subjects.

As discussed previously, a remote shutter release is almost essential, but it is also possible to fire the camera via your computer, with camera software such as Nikon's Camera Control Pro, which allows you to adjust virtually all of the camera controls remotely. This is well worth considering if your camera is in an awkward position, and it would be impractical to move it to make adjustments.

A hard floor is better than a carpeted floor since tripod legs will sink into the carpet, and may cause slight shifts of focus.

Subject Supports

Depending on the subject, you will need a range of supports for holding it. Laboratory retort stands and clamps are very useful, and available from various suppliers (see the Resources chapter). Small "helping hands" clamps used by electricians for holding wires being soldered are very useful for holding both specimens and reflectors. Laboratory "lab jacks" can be used to raise or lower specimens easily.

FIGURE 6.1 A "helping hand" clamp used by electricians for soldering wires can be a really useful device for holding specimens and reflectors.

One device, manufactured primarily for location work, but equally useful in the studio, is the Wimberley "Plamp," a 22-in.-long flexible arm that can be shortened or lengthened if required, with clamps at either end. One end can be attached to tripod legs, tabletops, and the like, while the other end can hold reflectors, lens shades, or plant stems.

Copy Stands

Although you will be using a tripod for much of your work, many subjects shot in the studio, such as coins or pond life for example, will be shot from directly above, looking down onto the subject. Instead of a tripod you might find a vertical copy stand much more practical. It holds the camera on a bracket attached to a vertical pole. The bracket can be raised or lowered to achieve coarse focus (though some stands do have a geared column), after which you can focus using the lens itself, or a focusing rail. You might find a right-angle finder attached to the viewfinder to be a useful accessory.

A simple copy stand can be constructed from an old enlarger baseboard and column.

Backgrounds

If a black background is required, then use high-quality black velvet. It is much better than black card for giving a solid black, and can be cleaned by steaming the reverse side with a boiling kettle to bring up the knap. Even when using velvet, try to keep any stray light from the surface though.

White backgrounds can be achieved with white card, though you will probably need to shine light on to it. Use a matte rather than glossy surface as you may get a specular reflection from the glossy surface. If the white background is some distance from the subject, or not enough light is shining on to it to make it pure white, then it will appear gray in the image, which can be very effective for some subjects. The precise shade of gray will depend on the camera-to-subject distance and light level.

If a natural, out-of-focus vegetation background is required, for example, make an A3 ink-jet print of an out-of-focus image of foliage. Print it onto matte surface paper and mount it on to card stock. It is worth keeping a range of these, with different color patterns.

Lighting

You will probably be using electronic flash for much of the time in the studio, but other types of light are available such as daylight, tungsten, and fiber

FIGURE 6.2 When shooting natural history subjects in an indoor studio setting, it is essential that the subject looks natural and unstressed. In this case, the vegetation used as props has been carefully chosen to match the natural heathland vegetation where this British Emperor moth would live. Camera: Nikon D300, natural light through window with reflector, $\frac{1}{60}$ sec. at f/11.

FIGURE 6.3 This tulip was lit from behind with a small flash unit to show the translucency of the petals, and from the front to show the structure of the stamens. Camera: Nikon D300, 105 mm Micro-Nikkor, two Nikon SB R-200 flash units, $\frac{1}{125}$ sec. at f/16.

FIGURE 6.4 Tendril from a Passion flower, showing change in direction of spiraling. I held the tendril in a "helping hand" clamp, and used an ink-jet print of an image of out-of-focus vegetation as the background. Camera: Nikon D300, 105 mm Micro-Nikkor at 1×, $\frac{1}{60}$ sec. at f/11.

optic sources. If your flash units do not have modeling facilities, then you can use small reading lamps to simulate the light given by the flash, though they rarely give a truly accurate result. Remember too that tungsten and quartz halogen light emit a lot of heat, which, when focused onto a small subject, can quickly damage it.

At some point, you will probably need to block out the light from windows so that you can assess precisely the light falling on the subject.

Don't ignore the possibilities of daylight in the studio, and make use of its unpredictability and variability. Tracing paper over the window on a sunny day can turn the window into a large soft box, making it excellent for flower portraits, for example, or shiny metallic objects. Reflectors can be used to direct light onto subjects. You will probably need long exposures when working with daylight.

FIGURE 6.5 This dental drill was held in a "helping hand" clamp, which could be tilted so that is was parallel to the image sensor. I enclosed it in a tent made from tracing paper, and used natural light through my study window to photograph it at a magnification of 5×. Camera: Canon 1000D, MP-E65 macro lens. 2 sec. at f/8.

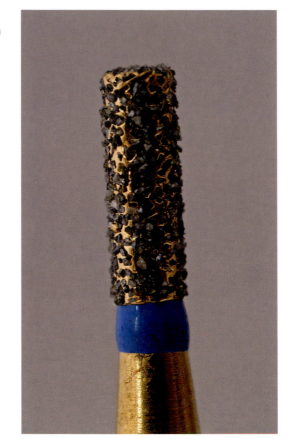

FIGURE 6.6 This Sea Biscuit shell was positioned underneath a vertical copy stand, and lit with diffuse light through the window. Camera: Nikon D300. 105 mm Micro-Nikkor. ½ sec. at f/22 with −1 stop exposure compensation.

Health and Safety

If you are photographing aquatic subjects in a tank, take great care not to allow water to get near electrical devices such as flash guns, and do not handle them with wet hands. Keep a towel nearby to dry your hands before touching your equipment.

Also, tanks of water can be surprisingly heavy, so take great care when lifting, and make sure that the table you are using can support the weight of the heavy tank. Place heavy tanks on a sheet of polystyrene to prevent cracking on an uneven surface.

Workflow and Image Processing

Although this book is primarily concerned with enabling you to get an image well lit and correctly exposed in the camera, thus requiring little postprocessing, there are certain operations that facilitate an efficient workflow and help improve image quality. Therefore, this relatively short chapter on image processing is included, but there are many books available with far more comprehensive discussions, both on general image-processing techniques and software-specific titles. Some of these are listed in the Resources chapter. For the purposes of this book we will use the example of Adobe Photoshop CS4, but many other software packages are available that will perform the same functions, such as Adobe Lightroom, Adobe Photoshop Elements, Nikon Capture NX, and PaintShop Pro.

Workflow

Developing an efficient, consistent, and predictable workflow will mean that any postprocessing of images is kept to a minimum, and that your images

can be found and retrieved easily at a later date. Technical issues such as color fidelity and sharpening all need to be part of your working method.

Camera Settings

The most important place to establish an efficient workflow is in the camera—getting the exposure and other settings right. As a general rule, use the lowest ISO setting and maximum quality settings available. The auto–white balance (AWB) is remarkably good in most cameras, but if you are using a specific light source such as tungsten or fluorescent, try using the specific setting for that light source in the camera white balance menu.

Histogram

The histogram on the back screen of the camera (see Figure 2.5 in Chapter 2) is an extremely useful (though not perfect) tool for checking correct exposure and subject contrast in the camera immediately after exposing an image. It represents a graphical display of the distribution of tones within an image. The bottom (x) axis of the graph represents a scale from black at the left end, to white at the right end. In image-processing terms, black has a value of 0, while pure white has a value of 255. The vertical (y) axis represents pixel density (luminance values)—that is, the number of pixels representing a particular value. Obviously not all images have similar tonal ranges, particularly those with white or black backgrounds, but an "average" image with black, white, and a good range of midtones will have a histogram similar to that shown in Figure 7.1. If you have a histogram of an "average" subject that is biased toward one end or the other, then that could imply that the exposure is incorrect. If the graph is falling off one end or the other, then no detail is present in those tones.

Some cameras can display three histograms, one for red, green, and blue (RGB), to help ascertain if there is a color cast in the highlights, for example. However, for most purposes the general RGB histogram is the most useful for assessing exposure.

It is worth keeping the "highlight flashing" facility turned on, whereby overexposed highlights with no detail flash on and off. You will want this to flash if you are aiming for a pure-white background.

In Adobe Photoshop, there are three sliders under the histogram (Image > Levels): one for the highlights, one for the midtones, and one for the shadows. Each of these can be moved independently. The correct position for the highlight and shadow slider is at the point where tones appear on the graph. A useful facility to assist with this process is the threshold mode. Make sure

the Preview button is checked, then hold down the Alt key while pressing either the shadow or highlight slider. The image now shows just the brightest or darkest areas. Place the slider at the point at which the highlight or shadow is on the threshold of appearing.

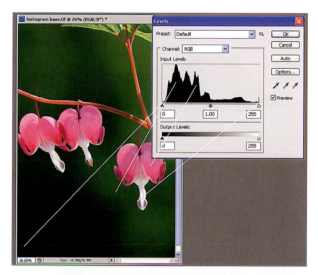

FIGURE 7.1 A histogram for the image of *Dicentra spectablis*, showing the position of the shadows, highlights, and two midtones.

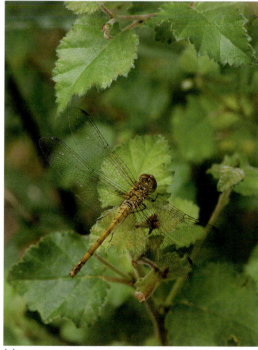

(a)

FIGURE 7.2 (a) The original image of this dragonfly was correctly exposed, but a little flat (low contrast). (b, c) Holding down the Alt key on the keyboard, the highlight slider was moved to the left to the point at which the white tones start to appear in the image. (d, e) The same exercise is then done with the left shadow slider. This is known as *thresholding*. The central slider is then moved to lighten or darken the whole image.

FIGURE 7.2 *Continued*

(b)

(c)

FIGURE 7.2 *Continued*

(d)

(e)

RAW or JPEG?

There may be no fundamental difference in quality between a RAW file and a well-exposed, maximum-quality JPEG file. With JPEG files, however, all camera settings such as sharpening and white balance are embedded into the file and cannot be undone, whereas RAW files offer a wide range of controls for modifying exposure, color balance, and the like. I would recommend that you use RAW files most of the time. Most cameras offer the option of recording both a JPEG and RAW version of each image, if desired. This offers the chance to view and assess images as quickly as with just JPEGs. If enhancements are required, then these can be done to the RAW files.

RAW files need to be processed in a RAW converter such as Adobe Camera Raw, BreezeBrowser, or Nikon Capture NX. The software nowadays is remarkably comprehensive, and offers facilities for changing exposure, color balance, and a host of other features.

Storage and Keywording

It is important that, as your collection of digital images grows, you are able to find them in the future. First, it is vital to have a backup so that if a hard disk fails or becomes corrupted, you have a copy of your important images. Software is available, such as Retrospect, for automatically backing up data on a regular basis, probably onto a separate hard drive.

FIGURE 7.3 (a) A RAW image of an Owl moth seen here in Adobe Camera Raw. Note the red areas on the butterfly wing (similar to the highlight flashing control on the camera) coupled with the red peak at the end of the histogram. (b) These are overexposed highlights that were easily removed by moving the exposure slider to the left, effectively giving the image around a two-thirds stop less exposure. Note the color space setting for Adobe RGB (1998) at the bottom of the screen.

(a)

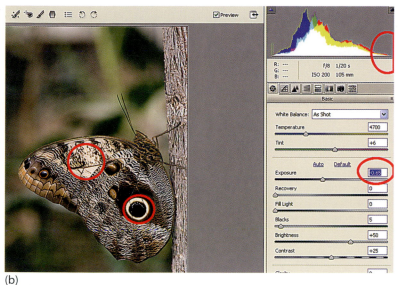

FIGURE 7.3 *Continued*

(b)

Make sure you have captioned your images and included keywords, so that you can search for them in future. Most image-processing packages, such as Adobe Photoshop, Elements, and Lightroom and Picasa have browsers where images can be captioned and keyworded. In Adobe Bridge (part of Photoshop and Elements) images can be ranked by color and/or a star rating so that you can, at a future date, search for all five-star green-labeled images of orchids shot in 2008, for example.

Color Management

Color management, from original image capture through to output, is a complex process, and many books have been written on the subject (see the Resources chapter for a few).

> **Color Space**
>
> The color space is the range of colors, or gamut, that can be displayed or reproduced by a particular system. There are two in common use: sRGB and Adobe RGB (1998). Many cameras, particularly at the top end of the range, have the ability to set this in one of the camera menus. As a general rule, if you are intending to only make prints, or use the images in Web sites or PowerPoint, for example, use sRGB. For images destined for publication, select Adobe RGB (1998). If you are shooting RAW files, this can be altered in the RAW converter software, such as Adobe Camera Raw (see Figure 7.3). Make sure that this color space is also set in Adobe Photoshop's Color Settings dialog box (Edit > Color Settings). This will at least help to ensure color consistency throughout your workflow.

FIGURE 7.4 Image metadata in the "file info" box in Adobe Photoshop. The image is captioned, and has a number of important keywords assigned to it. Each keyword can be searched for at a later date. It has also been given a blue label (which in my system indicates that it has been submitted to an agency) and has a ranking of four stars to act as a reminder of quality when sorting.

As already discussed, getting the color right at the taking stage is relatively easy, by using a gray-balancing device. After that, your images will be viewed on a computer monitor. These should be calibrated using a hardware calibration device such as a Datacolor Spyder or X-Rite i1 Display, and in a room with standardized viewing conditions. It is a good idea to fit a hood around the monitor so that no ambient light falls on the screen. These can be constructed easily from sheets of matte black card.

If you are going to print the images yourself, perhaps on an ink-jet printer, this too should be calibrated, and the profile for your specific paper loaded into Adobe Photoshop or other program that you are using (you will need a separate profile for each paper that you use). This will take into account the ink, paper, and other variables of your actual printer. Paper profiles are often supplied with the paper, downloaded from the manufacturer's Web site, or you can get profiles made specially by specialist companies (see the Resources chapter).

Output

Having exposed your image, enhanced it, and saved it, the final stage is output. Is the image going to be reproduced in a book or magazine, printed on an ink-jet or other form of printer, used in a Web site or PowerPoint presentation, sent to an image stock library for potential sale, or perhaps all of these? Each of these uses will have its own quality criteria. You will probably end up with several different versions of a file, each for a different application.

TABLE 7.1 Output Results

	Resolution	File Size	Sharpening	Other
Ink-jet print	180–240 dpi	Approx. 12 Mb for A4 print at 220 dpi	Yes	
Book/magazine reproduction	300 dpi	Approx. 24 Mb for A4 size reproduction	Check with publisher	Check other details with publisher/printer (e.g., RGB or CMYK)
Web, email, PowerPoint	72 dpi	Approx. 1.4 Mb for 12-in. wide image on screen	Yes	Save as JPEG
Stock library		48 Mb (color)	No	Check details with library

The image size box in Adobe Photoshop can be used to upsize or downsize (interpolate) images as appropriate. Ensure that the resample box is checked, and make sure to use bicubic interpolation when changing the size of your images. If your software has the options, use "bicubic sharper" for downsizing images and "bicubic smoother" for upsizing them. It is a testament to the quality of the software today that images can be upsized considerably, with remarkably little or no discernible loss in quality.

Ink-Jet Prints

For the highest quality prints use a specialist "photo printer," which usually has six inks rather than the standard four—cyan, magenta, yellow, and black, plus light magenta and light cyan. It is worth testing different resolutions, but for most photographic-quality prints, a resolution in the region of 200–240 dpi will give excellent results. Apply an unsharp mask to the image after any resizing has taken place.

Make sure to set the media type in the Printer dialog box, and the print resolution. If you are using a media type not listed in the dropdown menu, set the media type to "photo quality glossy film." This will put the least amount of ink onto the paper. Try to standardize on one or two media types, and don't be tempted by cheap ink refills. The profile supplied by the printer manufacturer will probably give incorrect colors if used with different inks.

FIGURE 7.5 The image size box in Adobe Photoshop, showing an original 34.9-Mb image resized to give a 10 × 6.642 image at 300 dpi. Note the reduction in file size from 34.9 Mb to 17.1 Mb.

FIGURE 7.6 I had a custom profile professionally made for my printer (called iTune PQGF) for my standard ink and paper combination, which is used every time I print. If you use several papers you will need a different profile for each one.

Photomechanical Reproduction

Book and magazines are printed with a screen for laying down a pattern of dots onto the page. Printing screens have different resolutions depending on the quality of the publication, defined in lines (of dots) per inch (lpi). Some examples are:

- Newspaper: 80–100 lpi
- Books: 133–150 lpi
- Magazines: 150–175 lpi

A useful rule of thumb is to send images to the publication at a resolution twice that of the printing screen resolution. For most purposes, a resolution of 300 dpi (2 × 150 lpi) is recommended, but again, it is worth checking with the client first. The final quality is dependent on a number of factors, including paper quality.

Check with the client too as to how they want the images prepared—RGB or CMYK, JPEG or TIFF, sharpened or not?

Web, PowerPoint, Screen Display

Images to be displayed on computer monitors in Web pages or PowerPoint presentations should be resized to 72 dpi (the resolution of most computer monitors).

Stock Library

Stock libraries, such as Alamy.com and Naturepl.com, hold collections of images that they hope to sell on behalf of their contributing photographers. As they want to be able to sell to as wide a range of clients and uses as possible, they require large image files—48 Mb being the usual recommended size for color images. Do not sharpen the images, as they may be sharpened by the client. Stock libraries will publish very specific guidelines for image submission, and must be studied carefully. Obviously, any images destined for publication must be technically perfect, well exposed, correct color, and sharp where appropriate.

Sharpening

The vast majority of digital images, even those from the most expensive cameras, will need sharpening at some stage. This is because manufacturers incorporate an "anti-aliasing" filter over the imaging sensor to prevent moiré patterns from occurring when photographing regular patterned objects such as check shirts. Most cameras incorporate a sharpening option in the menus. I would advise that this is turned off or kept to a minimum. If you are shooting RAW files it does not matter, but with JPEG files, once the file has been saved with sharpening, it cannot be removed later. Better sharpening options and

FIGURE 7.7 The Unsharp Mask dialog box in Adobe Photoshop. There are many differing opinions as to the correct method of sharpening images, and you should do tests with your images and your printer to see which you prefer.

techniques are available in programs such as Adobe Photoshop. Entire books have been written about sharpening, and there are numerous articles to be found on the Internet.

If you are sending images to picture libraries or for publication, the general rule is to not sharpen the images, as they will be sharpened at the printing stage. Check with the library or publication.

For ink-jet printing or for inputting into PowerPoint or Web sites, always sharpen images after all other operations have been carried out, in particular any resizing of the image. Entire books have been written about sharpening techniques, so all that will be done here is to give some recommendations as starting points for further experiments.

For ink-jet printing, use the Unsharp Mask filter (Filter > Sharpen > Unsharp Mask), often referred to as USM. There is great debate about sharpening settings, and every photographer seems to have his or her own preference. Start with settings of amount 200, radius 1, and threshold 3 and see if this suits your images. You will need to make a print to fully assess the effect. Do not rely on the monitor appearance.

For images prepared for Web use or PowerPoint shows, try the simple Sharpen filter (Filter > Sharpen), which should give a good result.

Subject Gallery

This chapter is a collection of some popular (and some less so) subjects and basic considerations for close-up and macro photography. It is by no means complete, but should cover many of the types of subjects you are likely to come across. There is usually no one right way of photographing a particular subject, though medical, forensic, and archeological photographers in particular will use standardized lighting and orientation so that subjects from different institutions can be compared. Scales are usually included in these images so that a comparative size can be obtained. Scales are available commercially (see the Resources chapter). Remember: If the subject has depth, it is important to align the scale with the main plane of focus within the subject.

Record Photography

I have used the rather bland term of *record photography* for images shot to record subjects in a technical and consistent way, to show as much detail and information as possible. Museums, hospitals, police, and many other areas need this type of imaging, where the main goal is to record in a consistent

way the various specimens that they deal with. This may often be over a period of time, where, for example, images of coins need to be recorded with consistent lighting, or where paleontologists need to know the precise size of a particular fossil. I have included here just a small selection of typical subjects.

FIGURE 8.1 As can be seen from the scale, this fossil Free-Swimming Crinoid is around 3 cm across. I used a grazed flash to highlight what relief and texture there was. Camera: Nikon D300, 105 mm Micro-Nikkor, 1/60 sec. at f/11.

FIGURE 8.2 I wanted to show this black Neolithic arrowhead against a contrasting background, so I used red felt. Lighting was from a single diffuse flash gun with a reflector. Camera: Nikon D300, 105 mm Micro-Nikkor, 1/60 sec. at f/8.

FIGURE 8.3 This hallmark on the end of a fork was lit with a single diffused flash and a silver reflector to maintain lighting directionality. Camera: Nikon D300, 105 mm Micro-Nikkor, $\frac{1}{60}$ sec. at f/8.

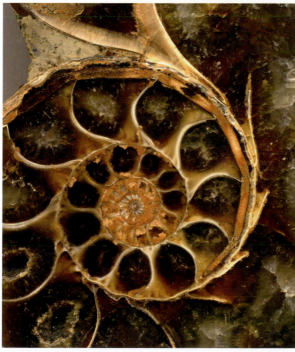

FIGURE 8.4 This shiny polished section of a fossil ammonite was taken in a light tent, using daylight through the window. Camera: Nikon D300, 105 mm Micro-Nikkor, $\frac{1}{15}$ sec. at f/8.

FIGURE 8.5 This ancient fly, fossilized in a drop of amber, is only 5-mm long. I tried several different methods of photographing it. The density of the amber makes getting sharp images of the fly difficult. (a) For this shot the amber was placed on a light box and photographed with a Canon MP-E65 mm macro lens to record it at a magnification of 4×. (b) For the next shot the amber was placed on a sheet of glass on my dark-field table. Two flash guns were angled from underneath; a third flash gun, heavily diffused, was aimed at it from above. Camera: Canon 1000D, MP-E65 mm macro lens.

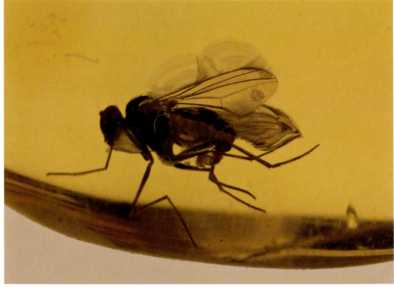

(a)

(b)

Polarized Light

Certain plastics become birefringent when stressed, and when placed between two cross-polarizing filters, reveal a wealth of colors and patterns. The technique, known as *photoelastic stress analysis*, was used by architects and engineers to reveal stresses within structures before they were built. Scale models of the object were constructed in various materials, including epoxy resins such as Araldite. Pressure applied to the model simulated real-life stresses. Most of this type of work is now carried out by computer simulation.

The polarizing materials formerly manufactured by the Polaroid Corporation are now made by 3M under the name Vikuiti. Other possible subjects to experiment with are Scotch tape strips criss-crossed across a sheet of glass, and crystals of various vitamins such as Vitamin C (make a saturated solution, spread a thin film of liquid over a piece of glass, and allow it to evaporate).

For these images I placed an A4-size sheet of polarizing material on a photographic light box, with the object placed directly on to it. A circular polarizing filter was attached to the lens and rotated until the background went black and the subject colors were at their most vivid.

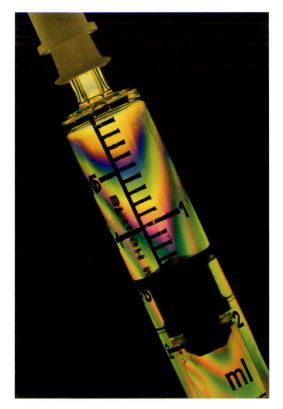

FIGURE 8.6 Plastic syringe in polarized light, showing stress patterns. Camera: Nikon D300, 105 mm Micro-Nikkor, 1 sec. at f/11.

FIGURE 8.7 Inside of CD case showing an interesting pattern of the CD "clip." Camera: Nikon D300, 105 mm Micro-Nikkor, 1 sec. at f/11.

FIGURE 8.8 Plastic medicine spoon. Camera: Nikon D300, 105 mm Micro-Nikkor, 1 sec. at f/11.

Time-Based Events and Sequences

Shooting a sequence can involve nothing more than shooting a series of images over a period of time—for example, plants growing, animals moving,

or subjects decaying. The sequence can be as little as two images (a before and after pair) or many images to produce a "time-lapse" sequence.

To show the changes over a period of time, it is important that both the camera position remains constant in relation to the subject, and the lighting is consistent.

If you are trying to illustrate how a Daffodil bud opens, for example, you will need to predict the size and position of the final stage, and work backwards from that when setting up the camera and lens. If necessary, leave extra space around the subject to account for larger-than-anticipated growth.

In the case of the Daffodil shown here, images were taken over an eight-hour period, at roughly two-hour intervals. Lighting was set up with an already open flower and then the unopened bud substituted for it. The stem was placed in a glass of water, and held in place by two retort clamps.

FIGURE 8.9 Sequence of four images of a Daffodil opening at two-hour intervals.

 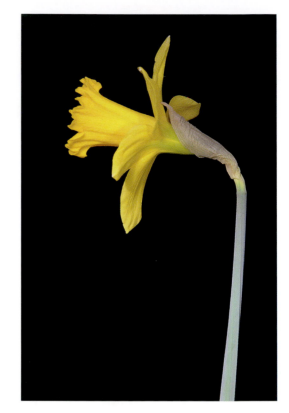

FIGURE 8.9 *Continued*

To illustrate better the way the flower changes position over a period of time, two of the images were blended together in Adobe Photoshop (any more than two in this case would have led to a very confusing image). Both images were opened, and the image of the open flower was opened and selected (Select > All). This was copied (Edit > Copy), then pasted onto the top of the first image (Edit > Paste), which created a layer on top of the first image. With the top layer as the active layer, the Blend command was set to lighten blend mode to effectively enable both images to be visible.

Aquatic Subjects

When photographing subjects in water, it is important that the water itself is as clear and has as little debris as possible. This will not always be possible with pond life, for example, where the subject may be constantly moving and disturbing any sediment. You usually will be photographing through glass as well, and this should be clean and scratch free. It is probably best to

(a)

FIGURE 8.10 (a) The Layers dialog box showing the lighten blend mode in Adobe Photoshop. (b) The final composite was flattened and enhanced slightly using levels and shadow/highlight controls in Adobe Photoshop.

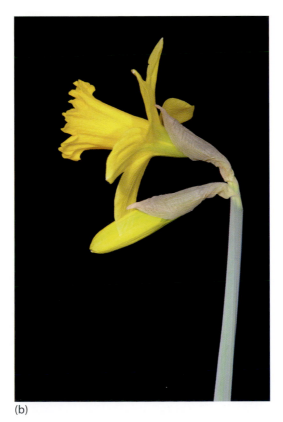

(b)

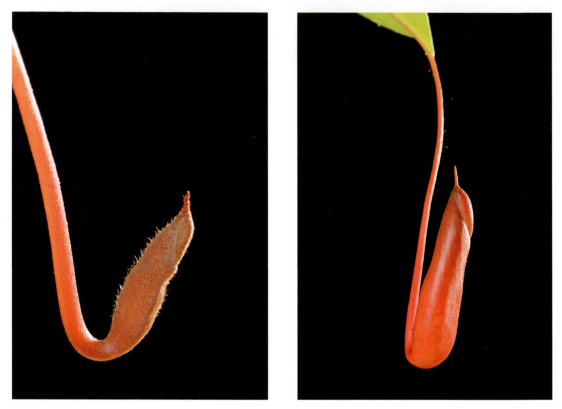

FIGURE 8.11 With this series, showing the development of a pitcher on an insectivorous *Nepenthes* plant, three different specimens were photographed using the same lighting and magnification.

keep the specimens in a holding tank, and transfer them to a photographic tank, with clean glass and filtered water. It is very important for the welfare of the subjects that the water temperature of the photographic tank is the same as the holding tank. You may need to fill the photographic tank some time before you commence photography, to allow time for any air bubbles to be released from plants or pebbles used as props. Use a camel hair brush to dislodge air bubbles from the surface of the glass or objects in the water.

You will need to mask any shiny or bright surfaces so that they do not reflect in the front glass. This is best done by making a hole in a piece of black card just large enough for the lens.

Electronic flash is by far the best source of lighting, both for freezing the movement of subjects, and because it does not generate excessive heat. If your flash unit has a modeling light, use this sparingly to minimize the heat. Some modern units use LEDs rather than tungsten lights for their modeling lights. For aquatic life such as fish and pond life, lighting the tank from above

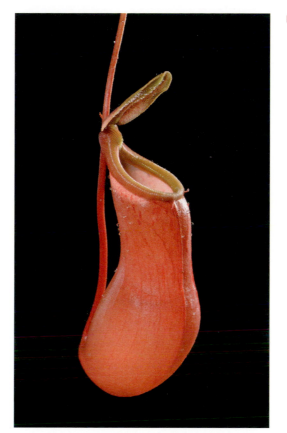

FIGURE 8.11 *Continued*

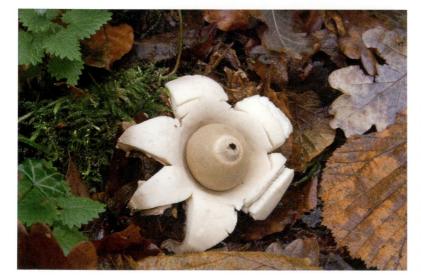

FIGURE 8.12 This scarce Earthstar fungus was found on a very dull day in December, among a group of a dozen or so. The light was terrible, but a long exposure of 2 seconds allowed me to get the required depth of field. Having photographed it in situ, I picked one specimen and brought it home to photograph it discharging its spores. Camera: Nikon D200. 105 mm Micro-Nikkor, 2 sec. at f/16.

143

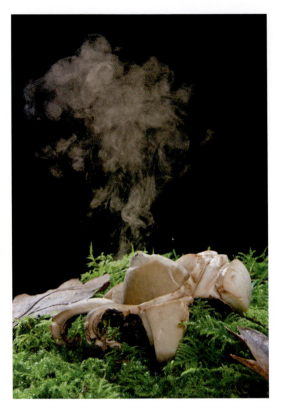

FIGURE 8.13 The fungus was placed among some leaves and moss about 30 cm from a black velvet background. Two small flash guns were placed behind it, angled so they would illuminate the spore cloud (dark field). Another two flash guns were arranged to light up the front of the specimen, one from above and to the left, the other acting as a fill-in to the right. A pipette was held in a laboratory retort stand and clamped above the fungus so that a drop of water would strike the fungus slightly to one side of the opening, allowing spores to be ejected. Single water drops were dropped onto the fungus while I tried to release the shutter at the right time to catch the spore cloud. Around 40 images were required to get 3 with a complete spore cloud. Although I used conventional flash guns, their effective speed of around $\frac{1}{500}$ second was sufficient to "freeze" the cloud in mid-air. Camera: Nikon D200, 105 mm Micro-Nikkor, 1/125 at f/11.

simulates natural daylight, and eliminates the possibility of reflection from the glass. If fill lighting is required, try directing the light source through the side of the tank. For frontal lighting keep the angle of the light at a narrow angle so that any reflection is not seen by the camera lens.

As can be seen in the diagram, depending on the focal length of the lens used, and its distance from the tank, it is possible that the back supports of the tank may appear in the image. If you are intending to do a lot of this work, you might consider constructing a special photographic tank where the back is longer than the front, matching the angle of view of the lens.

One interesting side effect of photographing subjects through water is that the effective depth of field is increased slightly due to the fact that the water

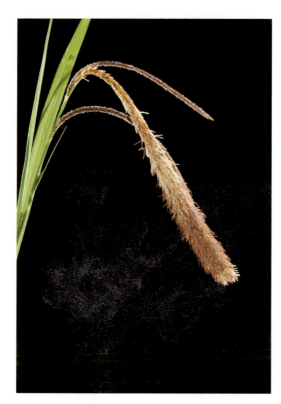

FIGURE 8.14 Pollen dispersing from Pendulous Sedge. I collected a stem of Pendulous Sedge just as it was starting to shed pollen. I clamped it in a retort stand about 35 cm from a black velvet background. Two Nikon R200 flash guns were placed behind it to light up the pollen, and a heavily diffused SB800 flash gun was positioned to the left and above the camera to provide frontal light. After doing a test shot to check exposure, I tapped the stem with a pencil to release the pollen, at the same time pressing the shutter release. Several attempts were needed to get the timing right. Camera: Nikon D300, 55 mm Micro-Nikkor, 1/125 sec. at f/22.

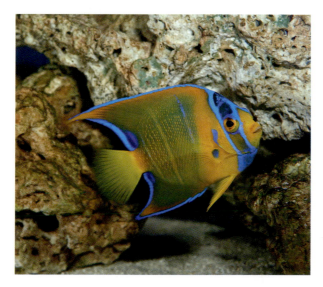

FIGURE 8.15 This beautiful Queen Angelfish was photographed against rock to try to emphasize the colors. Camera: Nikon D300, 60 mm Micro-Nikkor, 1/125 sec. at f/11; one Nikon SB-R200 held above the tank, one angled in from one side.

is denser—that is, has a higher refractive index—than air. This is why your legs look shorter and fatter in the bath! This fact is used by microscopists who often place a drop of immersion oil in between a microscope slide and the lens to increase depth of field.

FIGURE 8.16 The aptly named Lipstick Tang. You will need to practice your technique, and have quick reactions, to capture fast-moving fish in water. This is one area of macro photography where autofocus will be of use. Camera: Nikon D300, 60 mm Micro-Nikkor, $\frac{1}{125}$ sec. at f/11; one Nikon SB-R200 held above the tank, one angled in from one side.

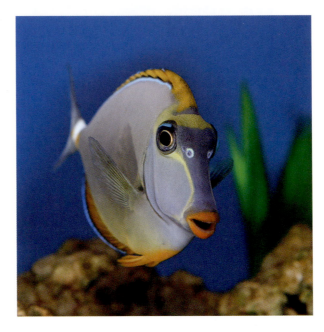

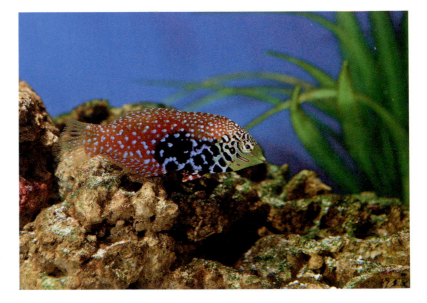

FIGURE 8.17 Spotted Dragon Wrasse. Although rather garish, the blue backgrounds used by tropical fishkeepers do seem appropriate for tropical fish. Camera: Nikon D300, 60 mm Micro-Nikkor, $\frac{1}{125}$ sec. at f/11; one Nikon SB-R200 held above the tank, one angled in from one side.

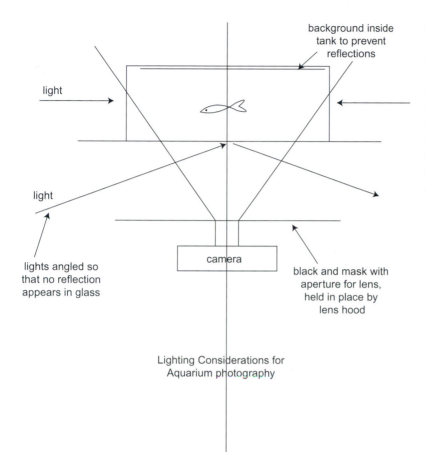

background inside
tank to prevent
reflections

light

light

lights angled so
that no reflection
appears in glass

camera

black and mask with
aperture for lens,
held in place by
lens hood

Lighting Considerations for
Aquarium photography

FIGURE 8.18 There are generally no problems when lighting from above or from the side with aquarium photography. When lighting from the front, ensure that the light source is at an acute angle to the glass. The angle at which it is reflected is equal to the angle at which it strikes the glass. Notice the angle of view of the lens, which may include the back support of the tank.

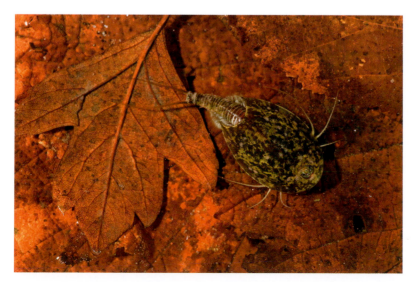

FIGURE 8.19 The *Triops cancriformis* is a rare tadpole shrimp living in just a few places in the United Kingdom. I first photographed it from above in the small aquarium in which it lived, against some decaying leaves, using two small flash guns, one from top left of the subject, and the other, weaker one acting as a fill in. Camera: Nikon D300, 105 mm Micro-Nikkor, 1/125 at f/11.

FIGURE 8.20 A dark-field shot of *Triops*. Camera: Nikon D300, 105 mm Micro-Nikkor, $\frac{1}{125}$ sec. at f/11. For lighting diagram refer to Fig. 5.6 in Chapter 5.

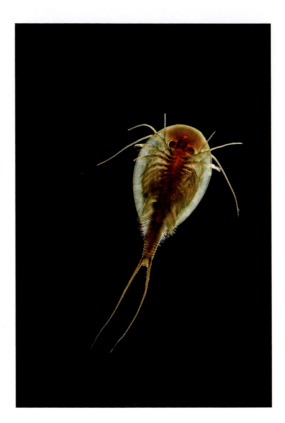

Abstracts

Most of this book has been concerned with the production of technically perfect close-up and macro images, and discussing how to get the very best quality from your equipment. The same techniques can be applied to the production of abstract close-ups, taken primarily for their pattern, shape, form, color, or texture. Newspapers and magazines have, over the years, had "What's this?" types of images, where extreme close-ups of everyday objects are pictured. I have included here a selection of images taken purely for their abstract nature, in the hope of inspiring you to do the same. All are simple close-ups with no specialized techniques.

FIGURE 8.21 Leaves have a wonderful pattern of veins, which look superb when backlit. I found this specimen in the glasshouse of a botanic garden, where the air was still, and there was no movement. I was able to set up a tripod underneath it and use a relatively long shutter speed ($\frac{1}{30}$ sec.).

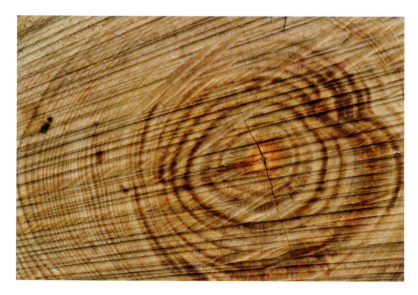

FIGURE 8.22 I was drawn to the way in which the pattern of parallel saw lines overlaid the tree rings of this newly felled tree.

FIGURE 8.23 I was taking general shots of this tarantula spider, but thought the hairy tangle of legs, head, and body made an interesting shot in its own right.

FIGURE 8.24 I was photographing this whole Satsuma as a record of this fungus growing over a period of time, but thought a much closer view of the wrinkled surface looked much more interesting! A single-grazed flash was used to accentuate the texture and relief.

FIGURE 8.25 I particularly liked the pattern of the spines on this hedgehog.

FIGURE 8.26 I liked the way one piece of this liverwort seemed to be making a break for freedom! Subjects such as mosses, lichens, and liverworts are not photographed nearly as much as they should be!

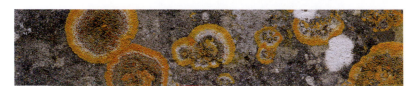

FIGURE 8.27 Not a true abstract, but an example of bringing together several techniques from the world of close-up and macro photography. This panoramic view of lichens on a gravestone was "stitched together" in Adobe Photoshop from six different shots using the Photomerge command (File > Automate > Photomerge), each overlapping by around 25 percent. The central column of the Benbo tripod was placed in a horizontal position (checked with a spirit level) and the camera mounted at one end so that it was parallel to the surface of the subject. The column was then moved by small amounts, tracking along the surface of the lichens. The original scene was approximately 225-mm (9-in.) long. Camera: Nikon D300, 105 mm Micro-Nikkor, $\frac{1}{125}$ sec. at f/11.

Resources

Stacking Images

Adobe Photoshop CS4: www.adobe.com

Combine ZM: www.hadleyweb.pwp.blueyonder.co.uk/CZM/combinezm.htm

Helicon Focus: www.heliconsoft.com/heliconfocus.html

Cameras and Lenses

Canon: www.canon.co.uk

Nikon: www.europe-nikon.com

Raynox close-up lenses: www.raynox.co.jp

Sigma: www.sigma-imaging-uk.com

Tamron: www.tamron.com/lenses

Zork MFS system: www.zoerk.com/

Camera Reviews

www.dpreview.com is a superb review Web site for digital cameras, as well as having a large archive of articles on a whole range of imaging topics.

Sensor Cleaning

There is a large range of sensor cleaning devices on the market, using both wet and dry methods, including:
www.visibledust.com
www.delkin.com/products/sensorscope/

Hardware

Depth-of-field calculator: www.dofmaster.com/dofjs.html

Diffraction calculator: www.cambridgeincolour.com/tutorials/diffraction-photography.htm

Scales for close-up photography: www.csiequipment.com

Adaptors and other coupling rings for lenses: www.srb-griturn.com

Polarizing materials: www.knightoptical.co.uk

Laboratory equipment (clamp stands, etc.): www.philipharris.co.uk

Wimberley PLAMP, support clamp: www.tripodhead.com/

Light tents: www.stevesphotoshop.co.uk

Kirk Photo: www.kirkphoto.com/

Really Right Stuff: http://reallyrightstuff.com

Novoflex bellows and other macro accessories, including flexible gooseneck arms: www.speedgraphic.co.uk

White balance devices (e.g., Kodak 18 percent gray cards) **and other color-management hardware and software:** www.colourconfidence.com

Printer profiling: Many paper manufacturers now supply generic profiles for their papers. Custom-made profiles can be obtained from www.imageplace.co.uk.

Folding reflectors and diffusers: www.lastolite.com

Manfrotto tripods: www.manfrotto.com

Gitzo tripods: www.gitzo.com

Benbo tripods: www.patersonphotographic.com/benbo-tripods.htm

Digital Imaging Books

General Adobe Photoshop

Evening, M. *Photoshop CS4 for Photographers*. Boston: Focal Press, 2008.

Galer, M., and P. Andrews. *Photoshop CS4: Essential Skills*. Boston: Focal Press, 2008.

RAW Files

Fraser, B., and J. Schewe. *Real World Camera Raw with Adobe Photoshop CS4*. Berkeley, CA: Peachpit Press, 2009.

Andrews, P. *The Complete Raw Workflow Guide*. Boston: Focal Press, 2007.

Books with Outstanding Close-Up and Macro Photography

Dalton, S. *Spiders: The Ultimate Predators*. Firefly Books, 2008.

Shaw, J. *John Shaw's Closeups in Nature*. Amphoto, 1987.

Thompson, R. *Close-Up on Insects: A Photographer's Guide*. Guild of Master Craftsmen, 2002.

Web Sites

There are many Web sites with excellent collections of articles on various topics such as Adobe Photoshop techniques and macro photography, as well as collections of close-up images. Three examples are:

Luminous Landscape: www.luminous-landscape.com

Nature Photographers Network: www.naturephotographers.net

Naturescapes: www.naturescapes.net

Photographers

There are a few inspirational photographers whose close-up and macro work is worth looking at:

Martin Amm: http://photo.net/photodb/member-photos?user_id=2109438

Stephen Dalton: www.stephendalton.co.uk

Ross Hoddinott: www.rosshoddinott.co.uk/

John Shaw: www.johnshawphoto.com/

Ghislain Simard: http://simpho.free.fr/

Robert Thompson: www.robertthompsonphotography.com

Glossary

Bokeh A Japanese word referring to the appearance and quality of out-of-focus areas of an image.

Dark-Field Lighting A lighting technique where the subject appears to glow against a pure-black background.

Depth of Field The amount of a subject, in front of and behind the main point of focus, that is acceptably sharp.

Diffraction An optical effect that can limit the total resolution of an image.

Diopter A unit of measurement of the optical power of a lens that is equal to the reciprocal of the focal length measured in meters (e.g., a 2 diopter lens brings rays of light from infinity to focus at $\frac{1}{2}$ meter).

dpi (dots per inch) The resolution of a printer. Also used to define the resolution of scanners, even though scanners have pixels.

Dynamic Range The range of light levels that can be recorded by an imaging sensor.

Effective Aperture The actual aperture at which the image is exposed. Calculated from: Relative Aperture \times (M + 1), where M is the magnification.

Exposure Value (EV) A value that denotes all combinations of camera shutter speed and relative aperture that give the same exposure.

JPEG (Joint Photographic Experts Group) An image file format where the image is compressed using a lossy compression. Different compression ratios can be applied, giving varying file sizes and resulting quality.

Magnification The relationship between the size of an object and the image size. A 2-cm object, reproduced at 20 cm on a print, is being magnified by 10\times.

ppi (pixels per inch) The number of pixels in a linear inch.

RAW Unprocessed image data stored as a RAW file. The data must be converted using a RAW converter such as Adobe Camera Raw.

Relative Aperture The f number inscribed on a lens.

Resolution A measure of how much detail an imaging system can record or reproduce.

Subject Brightness Range The range of tones within a subject, from shadow to highlight.

Unsharp Mask (USM) A form of image sharpening (probably the industry standard) found in image-processing programs such as Adobe Photoshop. The rather confusing name refers to an old printing term, whereby a soft-focus version of a photographic negative, sandwiched with the original, produced a sharper image overall.

Trentepohlia alga, growing on oak tree in bluebell wood. I wanted to show both the alga, and the habitat in which it was growing, so I used a wide-angle lens. Nikon D300 with Sigma 10–20 mm lens, set to 13 mm. $\frac{1}{125}$ sec @ f/11.

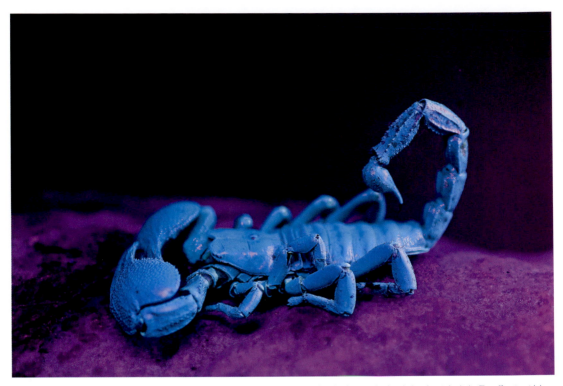

Ultraviolet fluorescence. Many substances, from minerals and insects, to ink and paint, glow (or fluoresce) when lit by ultraviolet light. The effect is widely used in the security industry for checking bank notes and "invisible" signatures in bank books. One particularly interesting subject is scorpions, though no one really knows why they react to ultraviolet light in this way! This specimen was lit by two ultraviolet lamps, (which are normally virtually invisible to the human eye) in a darkened room. The glow was quite dim, requiring a 4 second exposure.

Caution: when doing any work with ultraviolet lamps, take great care not to look directly at them—they can cause severe damage to the eye!

Kodak 14n camera. Tamron 90 mm macro lens, 4 seconds @ f/5.6

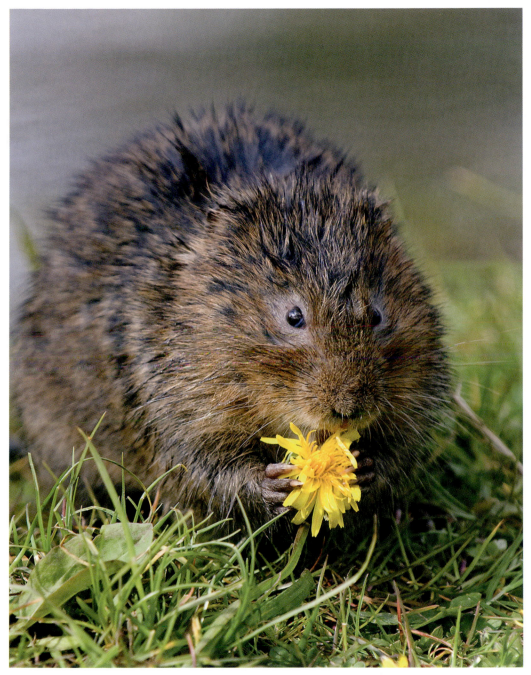

Water Vole eating Dandelion flower. I photographed this charming mammal with a 300 mm lens and 1.4 converter from a distance of around 2 meters. It was enjoying its snack so much it seemed oblivious to me switching lenses and tripods! Nikon D300, 300 mm lens with 1.4 tele-converter. $\frac{1}{400}$ sec @f/5.6.

Ramsons or Wild Garlic, growing in a wood in southern England. I used an extreme wide angle lens to show both close-ups of the lowers, and the habitat behind them. Nikon D300 with Sigma 10–20 mm lens, set to 10 mm. ¼ sec @ f/11

Leaves of Fittonia albivensis. Shots like this only really work when everything is sharp. I made sure to align the plane of the sensor with the main plane through the leaves. Nikon D300. 105 mm Micro-Nikkor lens. ⅙ sec @ f/11

Insectivorous Sundew plant, with damselfly prey. This plant was growing in a very wet bog, but I managed to position my tripod over the top of the plant to achieve maximum possible depth of field. Nikon D300. 105 mm Micro-Nikkor lens. $\frac{1}{80}$ sec @ f/11

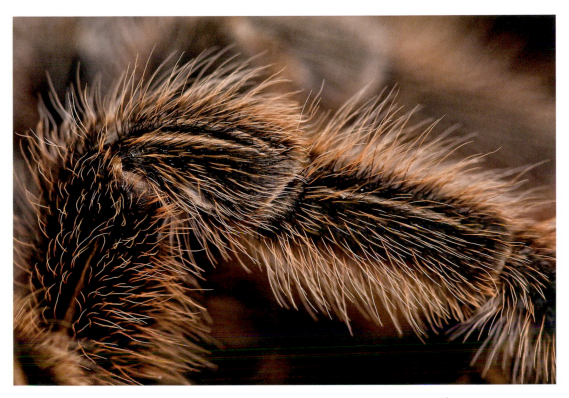

Leg of Chilean Rose Tarantula, showing hairs which it can eject to deter predators. Nikon D300. 105 mm Micro-Nikkor lens. $\frac{1}{60}$ sec @ f/11, twin flash setup.

Index